IMAGES
of America

# CHINESE IN
# HOLLYWOOD

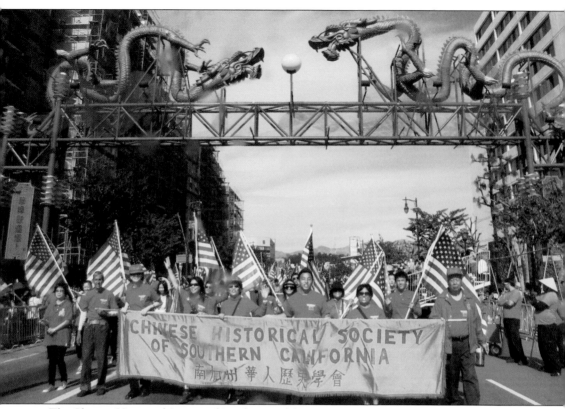

The Chinese Historical Society of Southern California (CHSSC) was organized in November 1975. The society has three purposes: to bring together people with a mutual interest in the important history and historical role of Chinese and Chinese Americans in Southern California; to pursue, preserve, and communicate knowledge of this history; and to promote the heritage of the Chinese and Chinese American community in support of a better appreciation of the rich, multicultural society of the United States. Pictured here are CHSSC members and board members marching in the 2013 Chinese New Year parade in Los Angeles Chinatown. For more information, visit www.chssc.org. (Courtesy of CHSSC.)

IMAGES
*of America*

# CHINESE IN HOLLYWOOD

Jenny Cho and the Chinese Historical
Society of Southern California

ARCADIA
PUBLISHING

Published by Arcadia Publishing
Charleston, South Carolina

Printed in the United States of America

Library of Congress Control Number: 2013953049

For all general information, please contact Arcadia Publishing:
Telephone 843-853-2070
Fax 843-853-0044
E-mail sales@arcadiapublishing.com
For customer service and orders:
Toll-Free 1-888-313-2665

Visit us on the Internet at www.arcadiapublishing.com

*This book is dedicated to Yush-Chye Hu, Mary Ebersole, and my late father, Chin-Kuei Cho.*

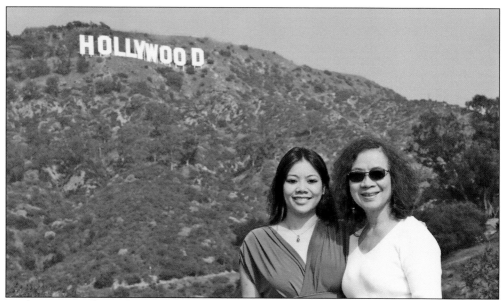

Author Jenny Cho and her mother, Yush-Chye Hu, visited Hollywood on February 6, 2013. (**HOLLYWOOD**™ & Design © 2013 Hollywood Chamber of Commerce. The Hollywood Sign and Hollywood Walk of Fame™ are trademarks and intellectual property of Hollywood Chamber of Commerce. All Rights Reserved.)

# CONTENTS

# ACKNOWLEDGMENTS

This book was made possible by: Nancy Kwan; Jack Ong; Shannon Lee; Kris Storti; Sydnie Wilson; Arthur Dong; Marlon K. Hom; Esther Lee Johnson; Jeff Chan; Al Leong; Brian Jamieson; Nancy Wong; Curtis Choy; Sue Fawn Chung; Jane Chung; Tyrus Wong; Kim Wong; Milton, Sherrill, and Jeff Quon; Pamela Tom; Roger LeRoque; Philip Lee; Holly Barnhill; Cindy Yee; Sandra Jones; James-John Kerigan; HBO; Julie Heath; Ashelyn Valdez; Larry McAllister; Roni Lubliner; Jessica Taylor; Margarita Diaz; Noreen Ong; DreamWorks Animation; Ed Ruscha; James McKee; the Betzwood Collection, the Brendlinger Library, Montgomery County Community College; Lawrence Greene; Joseph Eckhardt; Megan Bradford, National Air and Space Museum, Smithsonian Institution; Kate Igoe; Danett Crespo; Wayne Wang; Janet Yang; Amy Tan; Ming-Na Wen; Lauren Tom; Tamlyn Tomita; Rosalind Chao; Tsai Chin; Lisa Lu; Kieu Chinh; France Nuyen; Russell Wong; Yu Fei Hong; Howard Fong; Ronald Bass; John Woo; Spencer Baumgarten; Harry Shum Jr.; Marissa Upchurch; Keone Young; Page Leong; Beau Sia; Parry Shen; Walter, Eileen, Glenn, Chris, and Brandon SooHoo; Linda, Michael, Jordan, and Shannon Dang; Hayward SooHoo; James Hong; April Hong; East West Players; Tim Dang; Kit Carrido; Alvin Ing; Paul Wong; Michael Quan; Marc Wanamaker, Bison Archives; Frank Bren; S. Louisa Wei; Law Kar; Robin Lung; Mark and Betsy Scott; Christina Rice; Los Angeles Public Library; Suellen Cheng; Long Truong; Chinese American Museum; Webster Colcord; Shinae Yoon; Helen Kim; Abraham Ferrer; Visual Communications; Chevy Chen; James Sie; Brenda Hsueh; Elizabeth Sung; Patty Toy; Jason Tong; Quan Phung; Henry Chan; Alan Yang; Valerie Yaros; SAG-AFTRA; Donna Carrell; Jennifer Mitchell; Writers Guild of America; Joanne Lammers; David Pierce; Media History Digital Library; Jessie Petersen; TBS; Cliff Uyeda; Los Angeles Chinese Drum and Bugle Corps; Daniel Chang; Johanna Demetrakas; Kate Amend; Jean Tsien; William Hoy; Maysie Hoy; John Esaki; Evelyn Jung Wong; Kit-Lan Chu; Newton Chu; Leslie Li; the Chi family; Robert Montoya; Simon Elliott; Alex Tse; Will Tiao; Robin Walton; Teddy Chen Culver; Nathan Jung; Center for Asian American Media; Masashi Niwano; Christine Kwon; Teddy Zee; Barbara Yung; Shanghai Pearl; Robert Birchard; Robert F. Liu, ASC; Edward J. Pei, ASC; Holly Lowzik; Wallace Quon; Bo-Gay Tong Salvador; Peter SooHoo Sr. and Peter SooHoo Jr.; Leland Sun; Ann Limongello; Margaret Adamic; Maxine Hof; Tamara Khalef; Bob and May Wong; Robert Lee; Fenton Fong Eng; Simon Chhuor; Susan Dickson; Gilbert Hom; Gordon Hom; Winifred Lew; Don Loo; John Jung; Kelly Fong; Clement Lai; Eugene Moy; Pedro Chan; Steven Ng; Keith Hedlund; Melinda Holland; Catherine Wong Yee; Alecia Yee Simona; Susan Bollinger; Margie Lew; Adrienne Chi-en Telamaque; Eleanor Telamaque; O.C. Lee; Cy Wong; Donald Marion; Cheryl Holliday; Rowen Wu; William Chun-Hoon; Leslie See Leong; Lisa See; Peter Chen; Gloria Fong; William Chin; Stephen Raborn; Beverly Picazo; Lotus Leong; Baldwin Yen; Holly Hung; Jennifer Lee; Darrin McKie; Jessica Yi; Karl Morton; Shana Elson; Jamie Ford; Katherine Liu; Jody Hummer; Marjorie Liu; Harry Tong; Lisa See; Doreen Nakayama; Timothy Tau; Archie Kao; Kelvin Han Yee; Gregg Temkin; Academy of Motion Picture Arts and Sciences; Margaret Herrick Library; Don Lee; Lawreen Loeser; Faye Thompson; Jenny Romero; Michael Hartig; Marisa Duron; and Jonathan Wahl.

Thank you to the families of Violet and Marion Wong, Marcella Wong-Yasuhiro, Gala Wong Davis, and Gregory Mark.

Special acknowledgment also goes to Phil Yu at angrayasianman.com, Anna Almandrela at *The Huffington Post*, Ed Moy at examiner.com; Benjamin, Joan, and Jim Winjum; Francine Redada; Tom Eng; and Franklin Mah for their support of this project.

My eternal gratitude to David Wells and the invaluable resource of his blog: softfilm.blogspot.com. I could not have finished this without you.

Thank you to Arcadia Publishing staff past and present—Jeff Ruestche, Elizabeth Bray, and Jerry Roberts.

Much love to Yush-Chye Hu, Mary and Dennis Ebersole, Alexander, Joshua, Lizzy, and Karina.

Unless otherwise noted, images appear courtesy of the author.

Special thanks to the Ephemera Society of America for awarding the annual 2013 Jones Fellowship to CHSSC.

# INTRODUCTION

This book explores the contributions of Chinese and Chinese Americans to Hollywood films and chronicles those who lived or worked in the Hollywood neighborhood. It examines how Hollywood functions not only as a geographical area but also as a conceptual idea as the entertainment capital of the world.

The first chapter illuminates the early years of Chinese and Chinese Americans during the silent-film era and before World War II. As reflected by Grauman's Chinese Theatre and films such as D.W. Griffith's *Broken Blossoms* (1919), Hollywood was fascinated with Chinese culture. Yet Hollywood films often created or perpetuated stereotypes of Chinese characters as exotic foreigners, submissive types, or evil villains. In the 21st century, these stereotypes have yet to fade, but the call to create meaningful stories about Chinese and Chinese Americans rings louder than ever before.

Because of the practice of yellowface—in which non-Asian actors were hired to play Asian roles—Chinese American actors were not cast as leading characters in films such as *The Good Earth* or the Charlie Chan, Mr. Moto, or Fu Manchu series. Yet as early as 1916, the desire among Asian Americans to create realistic films about their experiences was reflected by *The Curse of Quon Gwon*, directed by a Chinese American woman, Marion Wong. Wong founded the Mandarin Film Company with the intention of producing films by and about Chinese Americans, but she was years ahead of her time and ultimately switched careers for the restaurant business.

Other courageous Chinese American filmmakers followed in Wong's footsteps. *Lotus Blossom* (1921) was directed by James B. Leong, an actor and director who founded Wah Ming Motion Picture Company with the goal of producing his own films. In 1933, Joseph Sunn Jue and Moon Kwan founded Grandview Film Company in San Francisco and produced over 80 films with Chinese cast and crews. Jue frequently collaborated with Esther Eng, a Chinese American female director who produced feature films in China and the United States.

The early years of American cinema also gave rise to silent-film stars such as Anna May Wong and Lady Tsen Mei. Lady Tsen Mei's films included *For the Freedom of the East* (1918) and *Lotus Blossom* (1921). Born Josephine Augusta Moy, the multiracial Lady Tsen Mei established a captivating persona as a singer and actress. Anna May Wong was born in Los Angeles and started acting as a teenager. Her career paralleled Hollywood's transition from the silent-film era to the talkies and, later, television. Wong and Leong even appeared together in the films *The Silk Bouquet* (1926) and *Lady from Chungking* (1942). Their contemporaries Keye Luke, Victor Sen Yung, and Benson Fong became stars in the Charlie Chan film series—not in the leading role, but as Chan's sons.

World War II provided numerous story lines that involved Asia and Asian characters. Chinese Americans became actively involved in supporting the war effort. Madame Chiang Kai-Shek's 1943 visit to Los Angeles and historic speech at the Hollywood Bowl reinforced America's support of China. The demand for Asian background extras gave work opportunities to Chinese of all age groups, and casting agents Tom Gubbins and Bessie Loo and, later, Guy Lee and Jadin Wong represented Asian American talent. With the repeal of California's antimiscegenation law in 1948 and the Alien Land Laws in 1952, the Chinese were able to marry outside of their ethnicity and purchase property. The Cold War era brought Chinese stars such as Li Li-Hua, Judy Dan, and Grace Chang to Hollywood. James Wong Howe made film history for being nominated for 10 Academy Awards in Cinematography and winning two—first for *The Rose Tattoo* (1955) and then for *Hud* (1963). Anna May Wong achieved a career milestone by becoming the first Asian American series regular on a television show, *The Gallery of Madame Liu-Tsong* (1951). Other actors followed suit to the small screen, including Sammee Tong in *Bachelor Father* (1957–1962) and Victor Sen Yung in *Bonanza* (1959–1973).

In 1961, Asian American actors attracted mainstream attention with the release of *Flower Drum Song*, the first Asian American musical film. The film catapulted a young Nancy Kwan to international movie stardom. Based on the novel by C.Y. Lee, *Flower Drum Song* was adapted by Richard Rodgers and Oscar Hammerstein and earned five Academy Award nominations. In 1965, the establishment of East West Players further reinforced the desire among Asian American actors to present diverse stories about their heritage.

The casting of Bruce Lee in the television series *The Green Hornet* (1966–1967) signified the rise of the first Chinese American action star. Lee became an international sensation with films such as *The Way of the Dragon* (1972) and *Enter the Dragon* (1973). Although his career was tragically cut short, his success established martial arts films as a distinct genre and paved the way for action stars such as Jackie Chan, Jet Li, Sammo Hung, and Stephen Chow.

Frustrated with negative Asian stereotypes and the lack of opportunities in Hollywood, Chinese Americans ventured to create independent films and performances that provided meaningful portrayals of their experiences. The Asian American movement paved the way for the preservation of Asian Pacific American history through films, documentaries, oral histories, literature, and more. In 1970, young Asian American filmmakers formed Visual Communications, a nonprofit organization with the mission of creating media by and about Asian Pacific Americans. The Asian American theater movement continued to evolve with the 1977 establishment of the Pan Asian Repertory Theater in New York City.

Wayne Wang's seminal film, *Chan is Missing* (1982), heralded the rise of a new generation of Chinese American directors. Wang also directed and produced *The Joy Luck Club* (1993), a landmark feature film featuring an all–Asian American cast. Based on the novel by Amy Tan, the film told four interweaving stories about Chinese American families. The 1990s also introduced the films of Ang Lee, a New York University graduate from Taiwan. Lee's early films—such as *The Wedding Banquet*, *Pushing Hands*, and *Eat Drink Man Woman*—explored stories about identity, intergenerational conflict, and sexuality. The films of Lee and Chinese directors Zhang Yimou and Chen Kaige received Academy Award nominations in the Foreign Language Film category.

The increasing popularity of Hong Kong films resulted in the successful crossover of stars Jackie Chan, Jet Li, Michelle Yeoh, and Chow Yun-Fat and director John Woo (who helmed *Face/Off* and *Mission: Impossible II*). Hong Kong filmmaker Wong Kar Wai explored themes of alienation, forbidden love, and sexuality in his films *Chungking Express*, *Happy Together*, and *In the Mood for Love*, and later made his Hollywood directorial debut with *My Blueberry Nights*.

Ang Lee gained a higher profile with the Academy Award–winning successes of *Crouching Tiger, Hidden Dragon* (2000), *Brokeback Mountain* (2005), and *Life of Pi* (2012). Director Justin Lin's feature film *Better Luck Tomorrow* (2002) introduced new Asian American voices while questioning long-held stereotypes. Director Alice Wu brought personal filmmaking to the foreground with her debut film, *Saving Face* (2004), about a young Chinese American woman grappling with her sexual identity. In 2013, two blockbuster releases were directed by Chinese American filmmakers: *G.I. Joe: Retaliation* by University of Southern California (USC) graduate Jon M. Chu and *Fast & Furious 6* by Justin Lin. Lin is a cofounder of *You Offend Me You Offend My Family* (www.yomyomf.com), a platform for Asian Pacific American (APA) filmmakers to create, discuss, and distribute media content online. Playwright David Henry Hwang collaborated with director Jeff Liu on Hwang's play *Yellowface* with support from yomyomf.com. The Internet has provided opportunities for Chinese and Chinese American talent to cultivate a market for projects that might not otherwise find an audience.

Many of this book's photographs were not taken in the geographical area of Hollywood but on film or television sets that employed Chinese and Chinese Americans. It is not possible to cover all of the contributions that Chinese and Chinese Americans have made in Hollywood, but this book provides a snapshot.

# One

# EARLY YEARS

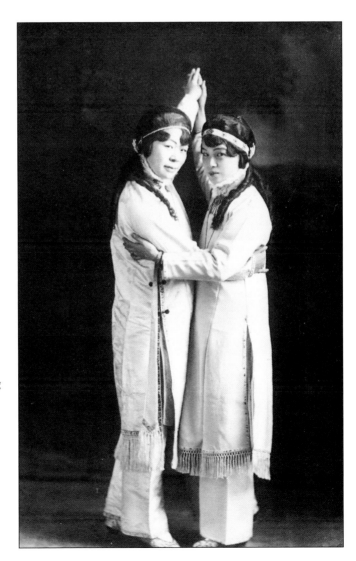

Filmmaker Marion Wong directed *The Curse of Quon Gwon*, the earliest known silent film to be written, produced, and directed by a Chinese American woman. Her sister-in-law Violet Wong (right) was the lead actor in the film. Based in Oakland, California, the two women were best friends and fans of tea dancing. "I had never seen any Chinese movies," Marion Wong said to the *Oakland Tribune* in 1916, "so I decided to introduce them to the world." (Courtesy of the Wong family.)

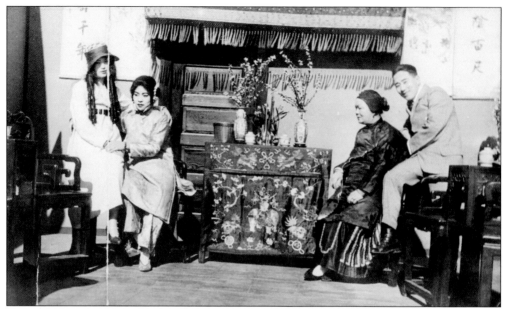

Directed by Marion Wong, *The Curse of Quon Gwon* was a groundbreaking film that explored bicultural identity from a Chinese American perspective in 1916. Pictured here are, from left to right, Violet Wong, Rose Wong, Chin Shee (also spelled Chin See), and Harvey Soo Hoo on set. Chin Shee was the director's beloved mother, and Soo Hoo was a family friend who married the director's cousin. (Courtesy of the Wong family.)

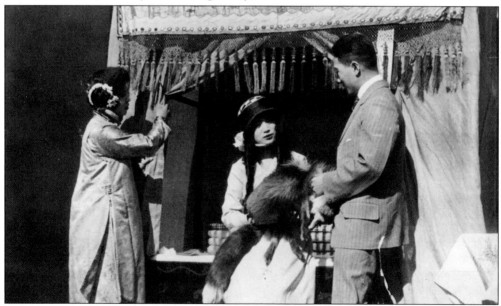

Pictured in the bedroom set of *The Curse of Quon Gwon* (1916) are Rose Wong as the maid (left), Violet Wong, and Harvey Soo Hoo. The film was directed by Marion Wong when she was just 21 years old, but it was viewed as a failure by the family because it did not generate a profit. The movie's remaining reels were transferred to 16-millimeter film by Gregory Mark with financial support from his grandmother, Violet Wong. With the help of filmmaker Arthur Dong, the film was added to the National Film Registry. (Courtesy of the Wong family.)

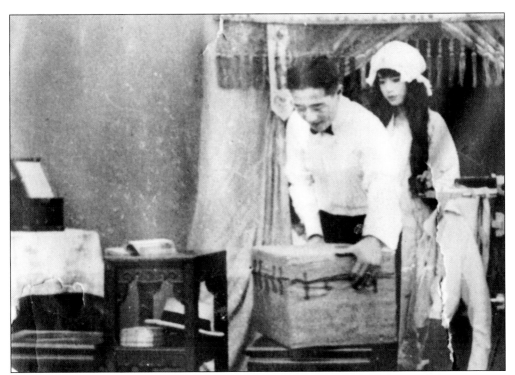

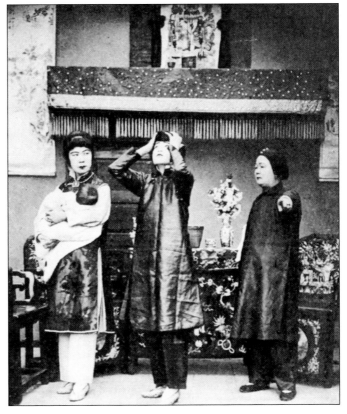

Harvey Soo Hoo holds a trunk in front of Violet Wong in *The Curse of Quon Gwon* (1916), produced by Marion Wong's Mandarin Film Company. One interpretation of the film is that an angry Chinese god places a curse on the characters as they undergo Westernization. Violet Wong's family theorizes that a visit by Charlie Chaplin's film crew to Oakland around 1915 may have inspired Marion Wong to try her hand at directing a film. (Courtesy of the Wong family.)

In this scene from *The Curse of Quon Gwon* (1916), director and third lead Marion Wong (left) plays the villain. (Courtesy of Media History Digital Library.)

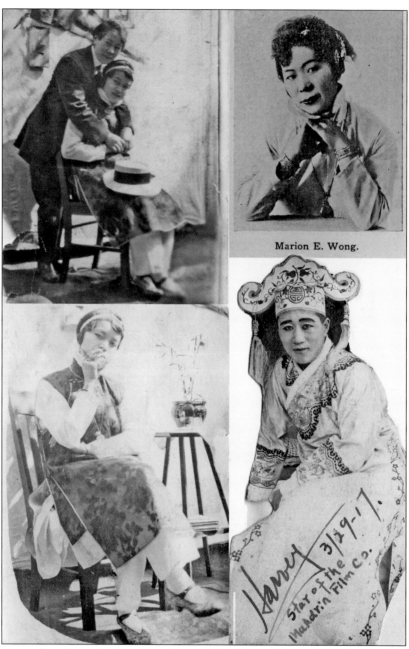

These four snapshots show the director and cast of *The Curse of Quon Gwon*. At top left is director Marion Wong in a suit embracing her sister-in-law and lead actor, Violet Wong. At top right is a headshot of Marion Wong that was published in *The Moving Picture World* (July 7, 1917) with an article about her film. Violet Wong (bottom left) smokes in a confident, defiant manner that predates the flapper trend. She showed the remaining reels of the film to her grandson, Gregory Mark, and told him to do something with them. Mark went on to become a professor of Asian American Studies at California State University, Sacramento. At bottom right is Harvey Soo Hoo in costume from March 29, 1917. (Courtesy of the Wong family; top right courtesy of Media History Digital Library.)

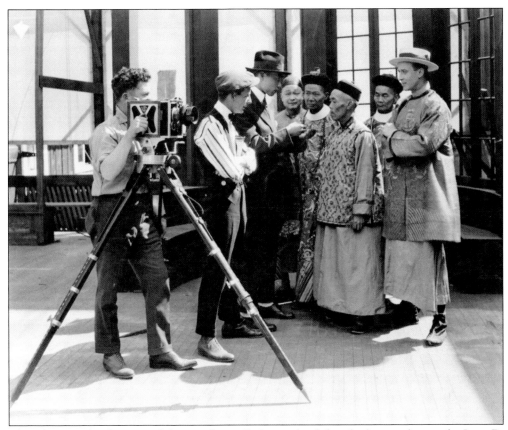

This photograph of actor and director James B. Leong (in fedora hat) was taken at the Jesse D. Hampton Studio on Santa Monica Boulevard during production of *The Pagan God* in April 1919. The film was released by Robertson-Cole through Exhibitors Mutual Distributing Corporation. Pictured here are cinematographer William C. Foster, director Park Frame (in striped shirt and cap), and actor H.B. Warner (in straw hat at right). Leong translates the director's instructions to a group of Chinese actors. (Courtesy of The Robert S. Birchard Collection.)

Actor and filmmaker James B. Leong directed Lady Tsen Mei in *Lotus Blossom* (1921). The caption underneath his photograph mistakenly identifies the film as *Lotus Flower*. Born Leong But-jung in Shanghai, Leong worked as a translator on *Broken Blossoms* (1919) and *The Pagan God* (1919) before directing *Lotus Blossom*. The premiere was held at the Alhambra Theater, and costumes were provided by the Oriental Costume Company (left). (Courtesy of Media History Digital Library.)

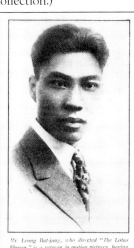

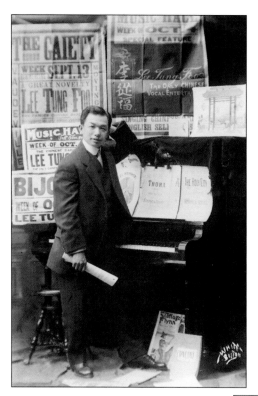

The first Chinese American to perform on the vaudeville stage, Lee Tung Foo charmed and confounded audiences between 1905 and 1919 with his operatic arias and Scottish impersonations. After retiring from the stage, he became a restaurateur in New York City. However, in 1936, he was persuaded to take a role in *The General Died at Dawn* and continued as a bit player for the next 26 years. (Courtesy of the California History Room, California State Library, Sacramento.)

This 1916 headline from *The Day Book* called Ah Wing the "first Chinese movie actor." Born in China, Ah Wing appeared with Etta Lee in *A Tale of Two Worlds* (1921), a film about the white adopted child of a Chinese servant who grows up in San Francisco's Chinatown. Wing played minor roles in silent films such as *Her Face Value* (1921), *The Masked Avenger* (1922), and *The Grub Stake* (1923). (Courtesy of the Library of Congress, Chronicling America: Historic American Newspapers.)

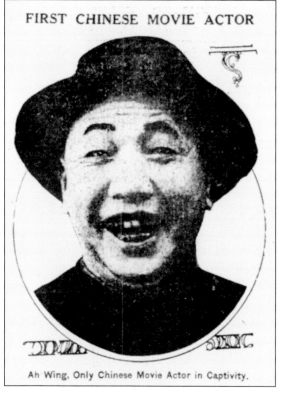

FIRST CHINESE MOVIE ACTOR

Ah Wing, Only Chinese Movie Actor in Captivity.

This advertisement in *The Moving Picture World* features the films of Charlie Fang that were available for distribution in 1918. Born in San Francisco, Charlie (or Charles) Fang worked as a steward on the USS *Olympia* as early as 1898. He was hired by the Scrantonia Photoplay Corporation, a motion picture company based in Scranton, Pennsylvania, to star in a series of silent short films. (Courtesy of Media History Digital Library.)

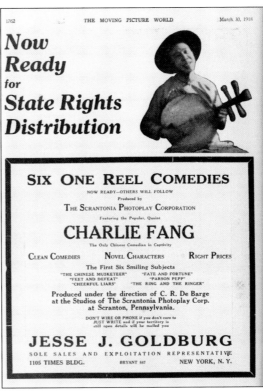

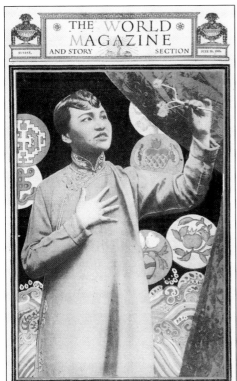

Alice Lee appeared on the cover of *The World Magazine* on June 30, 1918. Originally from China, she visited the World Pictures studio in West Fort Lee, New Jersey, to learn about the film industry. Her goal was to change and improve Chinese attitudes toward women. She was cast in *Mandarin's Gold* (1919), a silent film starring Kitty Gordon and Warner Oland (in one of his first yellowface roles). Rounding out the Chinese cast was comedian Charlie Fang, known as "the Chinese Musketeer." (Courtesy of Soft Film.)

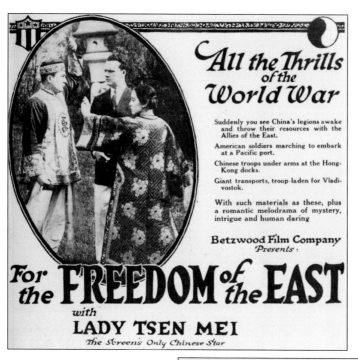

All the Thrills of the World War

Suddenly you see China's legions awake and throw their resources with the Allies of the East.

American soldiers marching to embark at a Pacific port.

Chinese troops under arms at the Hong-Kong docks.

Giant transports, troop-laden for Vladivostok.

With such materials as these, plus a romantic melodrama of mystery, intrigue and human daring

Betzwood Film Company Presents:

For the FREEDOM of the EAST

with LADY TSEN MEI

The Screen's Only Chinese Star

Lady Tsen Mei was the lead actor in the silent film *For the Freedom of the East* (1918), a patriotic drama directed by Ira M. Lowry. She played a Chinese princess who thwarts an assassination plot to protect her love interest, an American man. The film was produced by the Betzwood Film Company, a large studio along the Schuylkill River in Montgomery County, Pennsylvania, that was active until 1921. *The Moving Picture World* ran advertisements such as this one for the film. (Courtesy of Media History Digital Library.)

According to Scott Seligman's book *Three Tough Chinamen*, Lady Tsen Mei was the stage name of Josephine Augusta Moy, an adoptee born to a Chinese father and mulatto mother. She performed on the vaudeville circuit and sang opera at venues such as Park Theatre in New York City. Newspapers, delighted by the exotic sensation, dubbed her "the First Chinese Screen Star," "the Chinese Nightingale," and "the Chinese Prima Donna." She also starred in *Lotus Blossom* (1921), directed by Chinese American filmmaker James B. Leong. (Courtesy of the Betzwood Collection, the Brendlinger Library, Montgomery County Community College.)

This is a rare production still of Lady Tsen Mei on the set of *For the Freedom of the East* (1918), directed by Ira M. Lowry. The film was considered a follow-up to a previous film, *For the Freedom of the World* (1917). Lowry was enthusiastic about finding a Chinese actress to play the role of Princess Tsu and cast Lady Tsen Mei after seeing her performances on the concert stage. (Courtesy of the Betzwood Collection, the Brendlinger Library, Montgomery County Community College.)

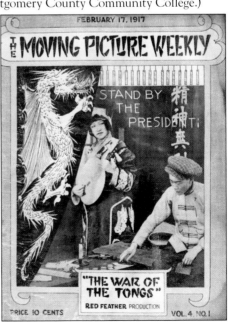

*The War of the Tongs* (1917) was a five-reel silent film written for an all-Chinese cast. Actress Lin Neong appeared on the cover of *The Moving Picture Weekly* to promote the film, which began shooting in Berkeley, California, in 1914. With no previous acting experience, Neong was cast by Arthur W. Rice, who set out to create a slate of projects including *The Chinese Lily* with Chinese actors and story lines. The film was hailed for its realistic portrayal of tong life. (Courtesy of Media History Digital Library.)

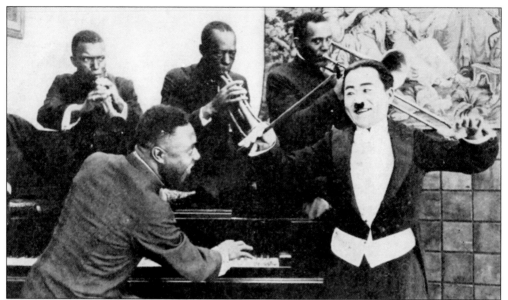

Chai Hong transitioned from working as a bellhop at the Alexandria Hotel in Los Angeles to becoming an actor known as the "Celestial Comedian." Here, he leads a band of musicians called the Darktown Strutters in a scene from *The Chinese Blues* (1919), produced by L-KO Kompany. Dubbed the "Chinese Chaplin," Hong appeared as Charlie in short films including *Charlie, the Little Daredevil* (1919), *Charlie, the Hero* (1919), *Charlie in Turkey* (1919), and others. (Courtesy of Media History Digital Library.)

Winter Blossom was cast in a leading role in the film *Whims of the Gods* (1921), also known as *What Ho, The Cook* (1921). Winter Blossom was the Orientalized stage name of actress Laska Winter, who was of French, Spanish, Irish, and German descent. Her costar was Jack Abbe (Yutaka Abe), an actor of Japanese descent. The film, though never released, was notable for presenting the story of a Chinese couple in a whimsical fairy-tale style. (Courtesy of Soft Film.)

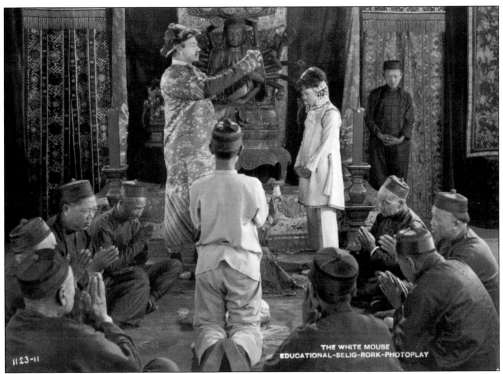

Pictured here, Bessie Wong played a Chinese slave girl in *The White Mouse* (1921), a Selig-Rork production that starred Wallace Beery in yellowface. In this film, Wong was joined by a young Anna May Wong (no relation), who was uncredited as a Chinese wife. Bessie Wong and sisters Anna May Wong and Lulu Wong were photographed together in the January 22, 1922, *San Francisco Chronicle* for the article "Young China Wide Awake." (Courtesy of Soft Film.)

With roots in San Francisco, Anna Chang started performing around age six and became known as the "Chinese Princess of Song." She sang with bandleader Paul Ash in San Francisco and Chicago and contracted with Publix Theatres for the stage revue *Hula Blues*. She appeared in the musical short *Two Little Chinese Maids* (1929) and in *Singapore Sue* (1932) with a young Cary Grant. This is an autographed headshot of Anna Chang from around 1928. (Photograph by Apeda Studio; courtesy of Soft Film.)

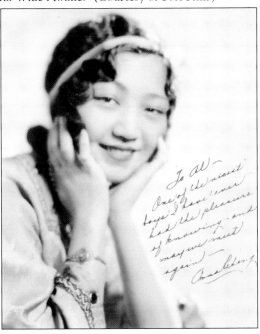

In 1923, *Motion Picture Classic* described actress Etta Lee as a "lovely peach blow half-caste girl" and "the only Eurasian girl" in movies. Born to a French mother and a Chinese father, Lee had been pursuing a teaching career in Hawaii when a chance encounter with a director's wife changed her life's course. She and Anna May Wong worked together on *The Toll of the Sea* (1922) and *The Thief of Bagdad* (1924), and she appeared with actor/director James B. Leong in *The Remittance Woman* (1923). After her marriage, she mostly retired from acting; her death notice in 1956 listed her married name as Etta Lee Brown. The photograph below is Etta Lee from *The Dressmaker from Paris* (1925). (Left, courtesy of Media History Digital Library; below, courtesy of Soft Film.)

Jue Quon Tai (third from right) was a vaudeville singer and the reigning social queen of Hollywood. As early as 1915, she was performing at the Orpheum in San Francisco and the Pantages Theatre in Salt Lake City. She eventually settled down with her husband, director Harry Lachman. This photograph with actor Edward G. Robinson (second from left) was taken at a party in Jue and Lachman's Beverly Hills home. (Courtesy of Michael Quan.)

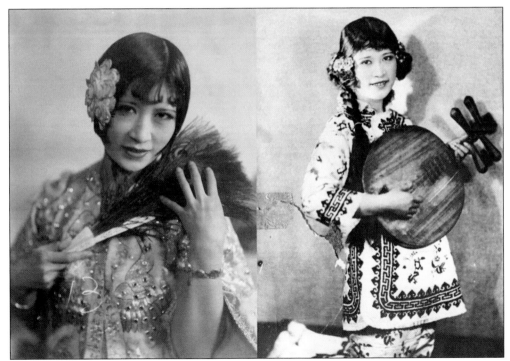

Nicknamed the "Voice of the Orient," So Tai Jue (also known as Alice Jewel) was a vaudeville singer and Jue Quon Tai's sister. In 1927, So Tai Jue appeared with an all–Asian American cast in *Ching-A-Ling* at the Shubert Playhouse in Wilmington, Delaware. She performed with Honorable Wu and his "Chinese Showboat" vaudeville act in several cities. Her radio debut was on the show *Jay C. Flippen-cies* on the Columbia network in 1932. (Courtesy of Michael Quan.)

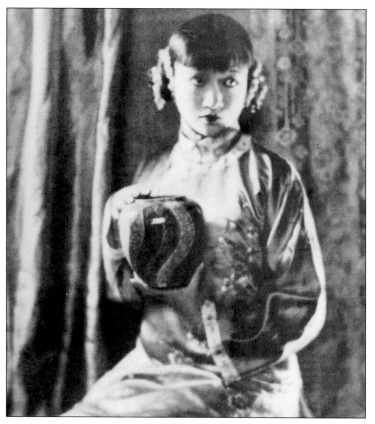

Anna May Wong (1905–1961) was inspired to pursue an acting career by the film productions shot near her family's laundry on Marchessault Street in Old Chinatown. With an estimated 72 film and television roles, Wong's career parallels Hollywood's transition from the silent-film era to the talkies. She was cast as an extra on *The Red Lantern* (1919), which led to small parts in films such as *Outside the Law* (1920), *A Tale of Two Worlds* (1921), and costarring in *Bits of Life* (1921) with Lon Chaney. (Photograph by Freulich; courtesy of Media History Digital Library.)

Producer, director, poet, dramatist, and educator Moon Kwan (left) collaborated with Liu Yu Ching (right) on *Pieces of China*, a travelogue produced by Isaac O. Upham. Dubbed the "Kipling of China," Kwan cofounded Grandview Film Company with Joseph Sunn Jue. Liu Yu Ching was known as "Giant Liu" and reportedly stood eight feet, six inches tall. He played the Tangani high priest in *Tarzan and the Golden Lion* (1927). (Courtesy of San Diego History Center.)

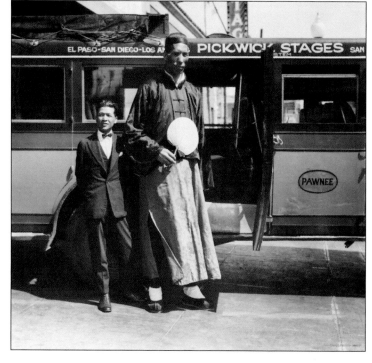

Anna May Wong received rave reviews in *The Toll of the Sea* (1922) for her portrayal of Lotus Flower, the tragic Chinese heroine who gets pregnant by an American white man in China and then drowns herself in the ocean after giving up her baby to the man and his wife. Directed by Chester M. Franklin and written by female screenwriter Frances Marion, who adapted the story from *Madame Butterfly*, the film was not only a milestone in Wong's career as her first leading role but also showcased a new film-color process. (Courtesy of the collections of the Margaret Herrick Library.)

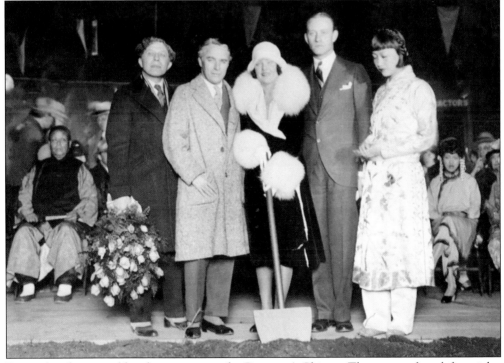

Pictured at the ground-breaking ceremony for Grauman's Chinese Theatre are, from left to right, namesake Sid Grauman, Charlie Chaplin, Norma Talmadge, Conrad Nagel, and Anna May Wong. The theater held its grand opening on May 18, 1927, with a screening of Cecil B. DeMille's *The King of Kings*. (Courtesy of Marc Wanamaker/Bison Archives.)

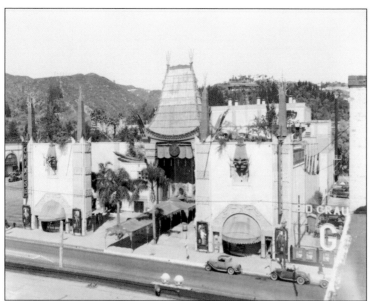

Located at 6925 Hollywood Boulevard, Grauman's Chinese Theatre has undergone major stylistic renovations since this 1928 photograph. In 1973, it became Mann's Chinese Theatre. In 2013, ownership changed again, and it became TCL Chinese Theatre. (Courtesy of Marc Wanamaker/ Bison Archives.)

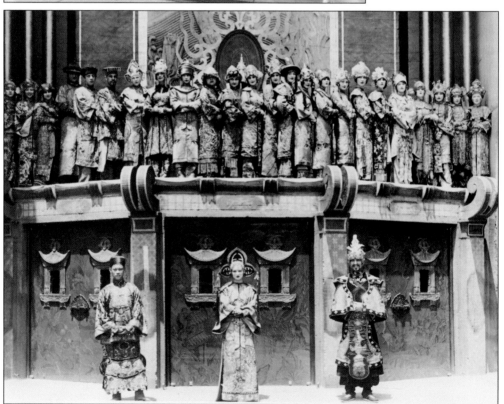

A multicultural group of ushers and usherettes line the entrance at Grauman's Chinese Theatre during its grand opening in 1927. Director and poet Moon Kwan oversaw the theater's Chinese decorations, which included Chinese temple bells, pagodas, stone heaven dogs, and other artifacts from China. Along with its splashy premieres, the theater became famous for its handprint ceremonies of famous stars in the outdoor forecourt. (Courtesy of Marc Wanamaker/Bison Archives.)

# Two

# 1930s AND 1940s

The 1930s and 1940s ushered in a new era for Chinese in Hollywood. World War II and the Japanese invasion of China inspired multiple story lines in films. Chinese American soldiers fought and died for their country, and those at home participated in patriotic activities to support the war effort. This advertisement for the film *Heartaches* appeared in *Chinese Digest* on January 31, 1936. Produced by Esther Eng, Bruce Wong, and Quon Yum Lim for Cathay Pictures, the film starred Beal Wong (right) and Wei Kim Fong as an ill-fated couple.

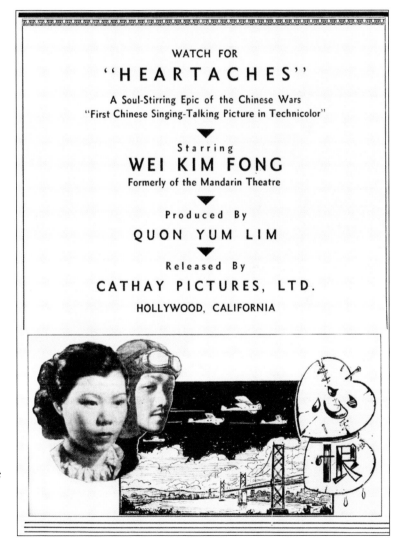

WATCH FOR

## ''HEARTACHES''

A Soul-Stirring Epic of the Chinese Wars
"First Chinese Singing-Talking Picture in Technicolor"

▼

Starring
## WEI KIM FONG
Formerly of the Mandarin Theatre

▼

Produced By
## QUON YUM LIM

▼

Released By
## CATHAY PICTURES, LTD.
HOLLYWOOD, CALIFORNIA

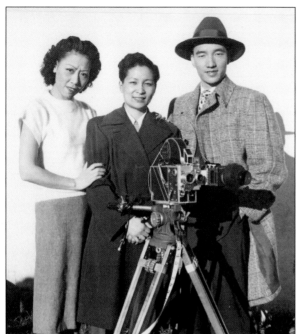

Pictured here are, from left to right, Siu Fei Fei, Esther Eng, and Ronald Liu. By age 35, Eng had directed nine feature films, a notable accomplishment for any filmmaker, but all the more remarkable for a Chinese American woman in the 1930s and 1940s. Her films included *Golden Gate Girl* (1941), with a baby Bruce Lee, and *Mad Fire, Mad Love* (1949), shot in Hawaii. (Courtesy of the Esther Eng photograph collections of S.Y. Louisa Wei, Law Kar, and Frank Bren.)

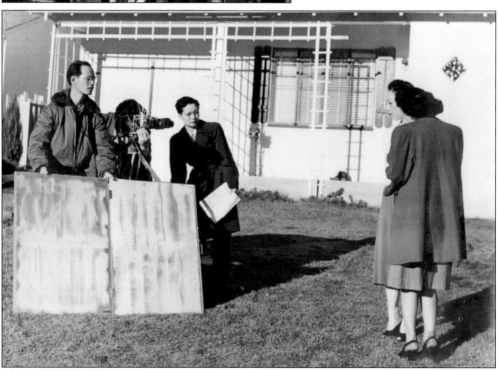

This photograph shows Chinese American film director/writer/producer Esther Eng directing a scene from her 1948 feature *Back Street* (also known as *Too Late for Springtime*). Eng is the subject of the documentary *Golden Gate, Silver Light*, directed by S.Y. Louisa Wei. Film historian Frank Bren wrote an article on Esther Eng and created the Web site www.estherengstory.com in her honor. (Courtesy of the Esther Eng photograph collections of S.Y. Louisa Wei, Law Kar, and Frank Bren.)

Joseph Sunn Jue cofounded Grandview Film Company (Grandview Motion Picture Company) with Moon Kwan in San Francisco. Grandview produced numerous films, including one of the first Cantonese talkies. Nicknamed the "Darryl Zanuck of Chinatown," Jue established Grandview Theatre in San Francisco's Chinatown to screen the studio's films. Shooting *She's My Gal* are cameraman Joseph Jue (Jue's son), actress Patricia Joe, and Jue. Joe acted in almost 200 films. (Courtesy of Hong Kong Film Archive.)

Olive Young welcomes the legendary Mei Lan-Fang on his visit to Los Angeles in 1930. One of the most famous Chinese opera performers of the 20th century, Mei introduced Peking opera to audiences around the world through his international tours. His admirer Olive Young, a Chinese American born in Missouri, was a film star in Shanghai during the mid-1920s. After returning to the US in 1929, she tried working in Hollywood without much success and ended up traveling the nightclub circuit as a blues singer until her untimely death in 1940. (Courtesy of the Los Angeles Public Library Photo Collection.)

AFTER THE SHOW LET'S GO TO THE

# CHINESE GARDEN CAFE

6313 HOLLYWOOD BLVD AT VINE — NEAR THEATRE

DINE and DANCE

## Tempting Chinese & American Dishes

POPULAR PRICES

Free Parking at N. W. Corner Hollywood Blvd. and Vine.....

Phone GRanite 6387 if you wish food delivered to you.

NO COVER CHARGE

Located at 6313 Hollywood Boulevard, Chinese Garden Café was owned by the Leong family, who also ran Soochow Restaurant in Los Angeles Chinatown. Gilbert Leong was a prominent architect and entrepreneur and helped found East West Bank. He designed the Chinese Methodist Church, the First Chinese Baptist Church, Kong Chow Association and Temple in Chinatown, the CHSSC logo, and several houses and buildings in Los Angeles. (Courtesy of Leslee See Leong.)

*D*ELIGHTFULLY charming are the beautiful Chinese girls who serve you at the Ivar House.

Ivar House, located at 1737 Ivar Avenue in Hollywood, employed Chinese workers such as this young lady. Operated by Orsina Gray Thompson, Ivar House included a garden that stretched over one acre as well as a restaurant, gift shop, flower shop, coffee shop, and bakery.

Cinematographer James Wong Howe operated Ching How Restaurant at 11386 Ventura Boulevard in North Hollywood. He is pictured here as "Hollywood's Ace Cameraman" on an advertisement that invited patrons to sample his delicious Chinese food. Nominated for 10 Academy Awards (and winning twice), Howe is one of the most successful Chinese Americans in the film industry. His wife, writer Sonora Babb, managed the restaurant; her sister handled the accounting; and actor Albert Wong worked as a waiter. Ching How's celebrity patrons included Marilyn Monroe, Clark Gable, Greta Garbo, Kirk Douglas, Lucille Ball and Desi Arnaz, Sessue Hayakawa, and more. (Courtesy of Don Lee and the James Wong Howe Estate.)

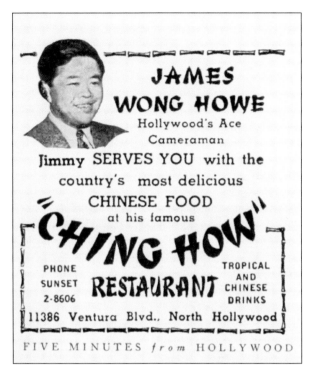

JAMES WONG HOWE
Hollywood's Ace Cameraman

Jimmy SERVES YOU with the country's most delicious CHINESE FOOD at his famous

"CHING HOW" RESTAURANT

PHONE SUNSET 2-8606

TROPICAL AND CHINESE DRINKS

11386 Ventura Blvd., North Hollywood

FIVE MINUTES *from* HOLLYWOOD

In 1946, actor Benson Fong opened the first Ah Fong's restaurant in Hollywood. With its success, Fong established a chain of restaurants throughout Southern California. The idea was suggested to him by Gregory Peck after they shot *The Keys of the Kingdom* together. This image of Ah Fong's restaurant on Sunset Boulevard is a detail from artist Ed Ruscha's book *Every Building on the Sunset Strip*, published in 1966. (© Ed Ruscha. Courtesy of the artist and Gagosian Gallery.)

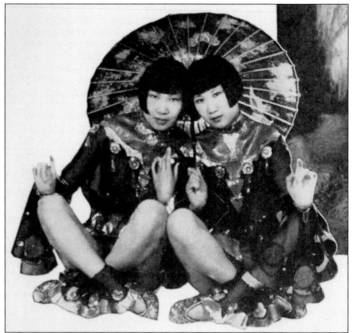

Known as the "Chinese twins," Bo Ling (right) and Bo Ching (left) were actually sisters who were born about three years apart. While growing up in Berkeley, California, they were encouraged to sing, dance, and play piano by their parents. The sisters migrated to Hollywood to seek work in the talkies. They appeared in one of the Charlie Chan films with their mother, Oie Chan. They sang "Side by Side" in the film *Climbing the Golden Stairs* and had speaking roles in *Myrt and Marge*. (Courtesy of Media History Digital Library.)

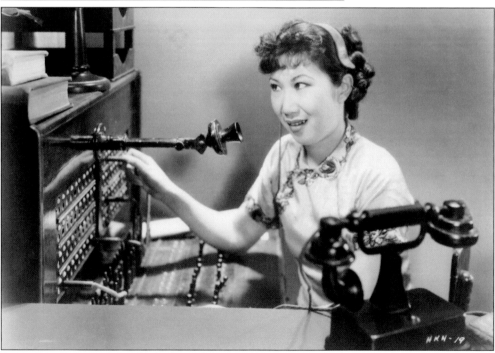

Bo Ling appeared as a hotel telephone operator in *Hong Kong Nights* (1935), produced by Walter Futter Productions. Bo Ling's original name was Bernice Park (also spelled Berenice), and her parents, Edward Park and Oie Chan, appeared in early Charlie Chan films. Bo Ling was married to actor Leroy Mason, who sold land to her sister Bo Ching and her husband in Northridge after they were prevented from buying property due to restrictive housing covenants. Bo Ling and Mason eventually separated and had no children. (Courtesy of Soft Film.)

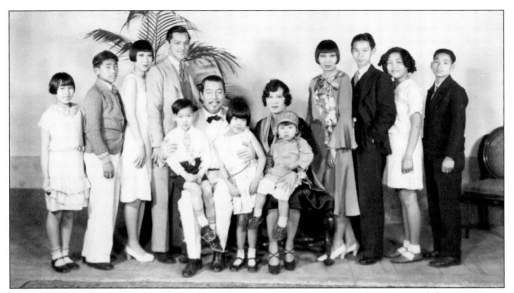

This photograph of Charlie Chan's "multitudinous blessings" includes an actual family. Sisters Bo Ling (third from left) and Bo Ching (fourth from right) were a singing and dancing duo that performed on vaudeville and film. Their mother, Oie "Florence" Chan, is seated to the right of Warner Oland, who played Charlie Chan in numerous films. (Courtesy of Bo-Gay Tong Salvador.)

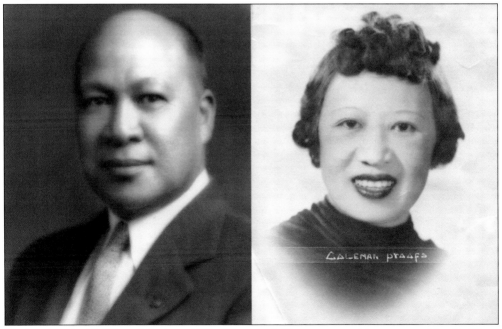

Husband and wife Edward Park and Oie "Florence" Chan appeared in separate Charlie Chan films. Born in San Francisco, Park was the first Chinese actor to play Charlie Chan. His wife played Mrs. Chan in *Charlie Chan's Greatest Case*. Park worked as an interpreter, established China Costume Co., and opened a restaurant on Alameda Street in Los Angeles. Daughters Bo Ling and Bo Ching were singers and actors and appeared with their mother in *Mr. Wu* and in the Charlie Chan film series. (Courtesy of Bo-Gay Tong Salvador.)

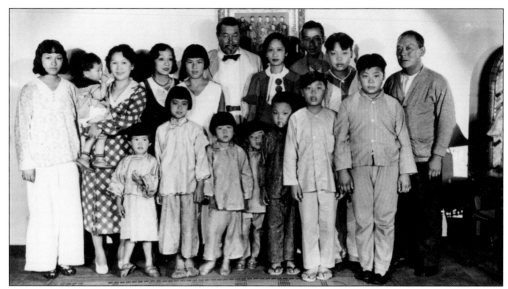

The Chinese American cast of *Charlie Chan's Greatest Case* poses with Warner Oland, who played Charlie Chan in numerous films. Along with *The Good Earth* and Fu Manchu films, the Charlie Chan films are among the most visible representations of a white actor in yellowface. At left in the row of children is Faye Lee. Jennie Lee can be seen in the second row holding Marjorie Lee. (Courtesy of the Los Angeles Public Library Photo Collection.)

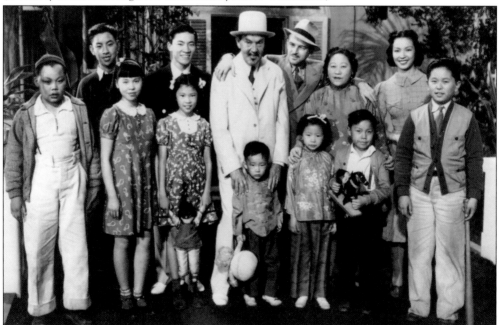

Although Charlie Chan was portrayed by a white actor in yellowface, the films were among the first to explore intergenerational dynamics between immigrant Chinese parents and their American-born offspring. Pictured here are, from left to right, (first row) David Dong, Barbara Jean Wong Lee, Faye Lee, Steven Gin, Marjorie Lee, unidentified, and Layne Tom Jr.; (second row) Sinclair Yip, Victor Sen Yung, Sidney Toler, unidentified, Grace Key (as Mrs. Chan), and Iris Wong. (Courtesy of the Los Angeles Public Library Photo Collection.)

*The Jade Mask* starred Edwin Luke as Charlie Chan's "Number Four Son," Eddie Chan, and Mantan Moreland as the chauffeur. After graduating from the University of Washington, Luke (the younger brother of Keye Luke) moved to Los Angeles and appeared in over 30 films, including *Blood Alley*. To supplement his income, he worked other jobs, including writing and editing at *The Hollywood Reporter*, and he later became a social worker. (Courtesy of MGM Media Licensing. *The Jade Mask* © 1944 Metro-Goldwyn-Mayer Studios, Inc. All Rights Reserved.)

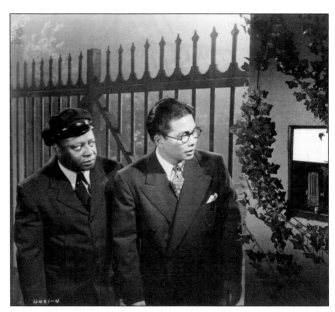

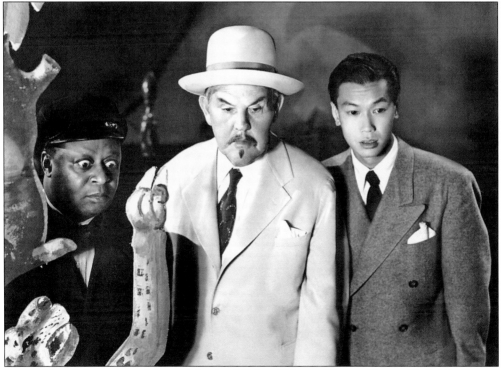

Pictured from left to right are Mantan Moreland, Sidney Toler, and Benson Fong in *Dark Alibi*. Benson Fong played "Number Three Son" Tommy Chan. After a chance encounter with a talent scout at a restaurant, Fong was given the opportunity to act in *Behind the Rising Sun*. Paramount Pictures signed him to a 10-week contract at $250 per week. During World War II, his career took off with the increased demand for Asian supporting players. After costarring in *The Keys of the Kingdom* with Gregory Peck, Fong established a chain of restaurants called Ah Fong's. (Licensed by: Warner Bros. Entertainment Inc. All Rights Reserved.)

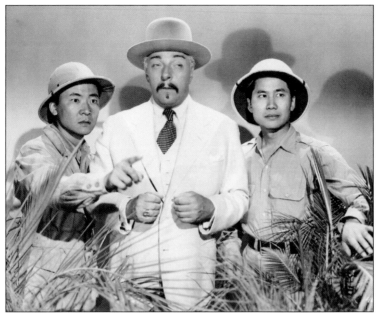

Victor Sen Yung (left), Roland Winters (center), and Keye Luke starred in *The Feathered Serpent* (1948). Born in San Francisco, Yung had been working as a chemical salesman when he was cast as "Number Two Son" Jimmy Chan. This was the only Charlie Chan film in which Yung and Luke appeared together. (Licensed by: Warner Bros. Entertainment Inc. All Rights Reserved.)

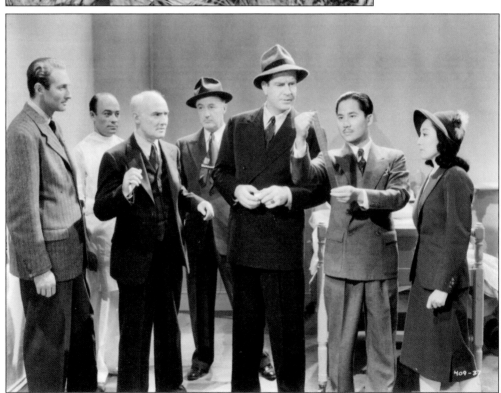

Second from right, Keye Luke played Det. James Lee Wong in *Phantom of Chinatown*, which broke ground by casting a Chinese American male lead in film noir. At right is Lotus Long, of Japanese and Hawaiian heritage, who changed her surname to avoid persecution during World War II. (Courtesy of MGM Media Licensing. *Phantom of Chinatown* © 1940 Metro-Goldwyn-Mayer Studios, Inc. All Rights Reserved.)

Dolores Del Rio

I t sounds like a fairy tale, but it's true: In the summer of 1934, 30-year-old Keye Luke, billboard designer and caricaturist for RKO Studios' publicity department, was whisked in front of the cameras for a supporting role opposite Greta Garbo in *The Painted Veil*. After more than a half-century of steady work in theatre, TV and feature films—most prominently as "Number One Son" Lee Chan in Warner Oland's *Charlie Chan* films of the 1930s, and the blind monk "Master Po" in the 1970s hit TV show *Kung Fu*—Luke played his final part in 1990 as Dr. Yang in Woody Allen's *Alice*, starring Mia Farrow.

In 1928, the year Luke arrived in Hollywood as an artist, famed WWI poet Lawrence Binyon, director of prints and drawings at the British Museum, declared "...in vitality of line, Mr. Keye Luke altogether surpasses [Aubrey] Beardsley...but I confess I fear for the future of this young artist if he remains in the West."

Jeanette MacDonald

James Gleason

# KEYE LUKE
### 1904-1991

Claudette Colbert

Luke did not return to China but, in 1934, his drawings of stars and featured players graced the first half-dozen issues of the Guild's new magazine.

The following year, he boldly became a member of the as yet unrecognized Guild. In 1965, he began six years of service on the Guild's board of directors. Luke died in 1991, and his star on Hollywood's Walk of Fame, awarded the month before his death, is located at 7030 Hollywood Blvd., a block west of the historic El Capitan Theatre.

Groucho Marx

The winter 2005 edition of *Screen Actor* published this tribute to Keye Luke (1904–1991) to celebrate his talents in art and acting. Born in China, Luke migrated with his family to Seattle, Washington, as a child. He attended art classes in high school and, after graduation, showed his portfolio to an advertising executive, which led to work for clients including Grauman's Chinese Theatre, hotels, catalogues such as Sears-Roebuck, and movie studios. He drew publicity portraits for celebrities at Fox and RKO Studios and was encouraged to pursue acting by his coworkers. He almost appeared as a romantic lead opposite Anna May Wong in *Hold for Shanghai*, but the project did not move forward. His former boss cast him in *The Painted Veil* with Greta Garbo and Warner Oland. He costarred with Oland several times as "Number One Son" in the Charlie Chan films. (Courtesy of SAG-AFTRA.)

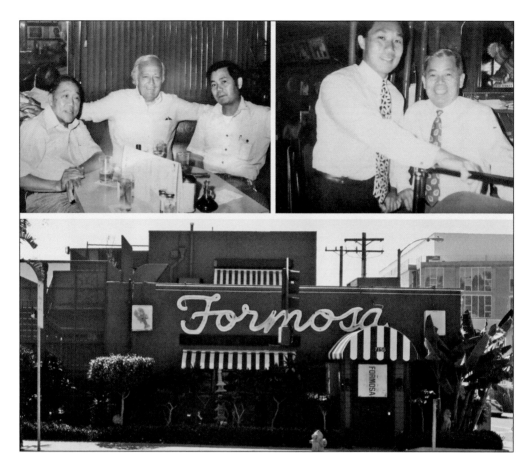

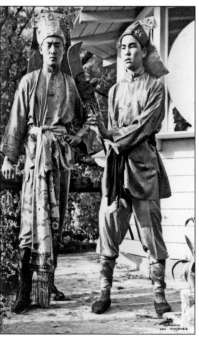

Located at 7156 Santa Monica Boulevard, Formosa Café dates back to 1925, when Jimmy Bernstein operated the business as the Red Post in a renovated red trolley car. Lem Quon worked in the kitchen and then took over ownership after Bernstein died. The restaurant was saved from demolition after the City of West Hollywood declared it to be a historic and cultural landmark. Third-generation owner Vincent Jung continues to run the family business. From left to right (top left) are Lem Quon, James Bacon, and William Jung. The top right photograph shows Vincent Jung (left) and William Jung. (Top, both courtesy of Vincent Jung; bottom, courtesy of Benjamin Winjum.)

Roland Got (left) and Johnny Yee donned Chinese costumes for occasional performances in China City in Los Angeles. Both were cast by Tom Gubbins for *The Good Earth*. Yee became a Navy veteran and active member of the Los Angeles Chinatown community. (Courtesy of the Los Angeles Public Library Photo Collection.)

Roland Lui (left) and Keye Luke (second from left) played the sons of O-Lan (Luise Rainer, seated) in *The Good Earth*. Luke was one of the most prolific Chinese American actors of the 20th century. William Law (right) was a wealthy San Francisco businessman and Chinese Six Companies officer who worked as a bit player for fun. Author Pearl S. Buck advocated for an all-Chinese cast to portray the characters in her novel, but white actors were hired in leading roles instead. The film employed hundreds of Chinese Americans as supporting characters and extras. (Licensed by: Warner Bros. Entertainment Inc. All Rights Reserved.)

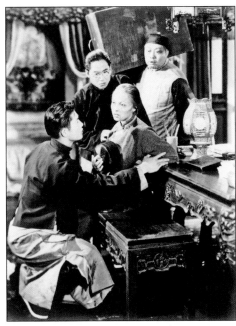

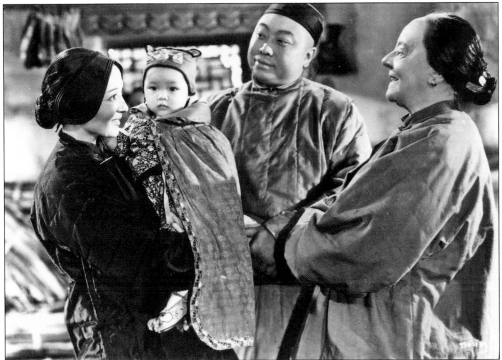

Pictured here are Luise Rainer holding young Betty SooHoo, William Law, and Walter Connolly. SooHoo plays O-Lan's baby son in the film. The media considered Anna May Wong to be a strong contender for the role of O-Lan, but her hopes were dashed after Paul Muni was cast as the leading man because of Motion Picture Production Code restrictions against Asian and white actors playing in romantic scenes together. Rainer was cast as O-Lan and won an Academy Award for the film. (Licensed by: Warner Bros. Entertainment Inc. All Rights Reserved.)

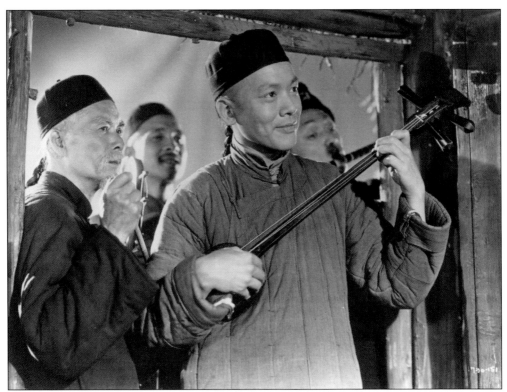

Standing next to Moy (Luke) Ming, Ching Wah Lee plays the *sanxian* (a Chinese banjo) in *The Good Earth* (1937). The multitalented Lee was an actor, writer, art dealer, tour guide, and cofounder of *Chinese Digest*, the first English-language weekly newspaper for Chinese Americans. Ming's other film appearances included the films *Let's Get Tough* and *Shadow of Chinatown*. (Licensed by: Warner Bros. Entertainment Inc. All Rights Reserved.)

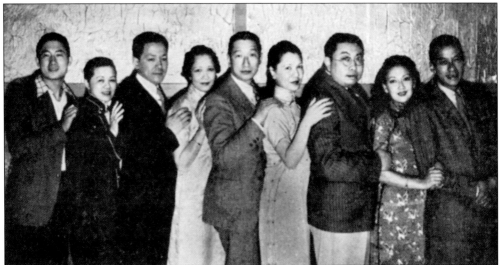

Many Chinese Americans were cast in supporting roles in *The Good Earth*. Pictured here are, from left to right, Roland Lui, Caroline Chew, Ching Wah Lee, Mary Wong, James Z.M. Lee, Soo Yong, William Law, Lotus Liu, and Frank Tang. (Courtesy of Soft Film.)

Casting recruiter Tom Gubbins (right) adjusts the wardrobe of actor Luke Chan. The increasing number of Asian story lines in movies required growing numbers of Asian extras. Gubbins filled casting calls for Asian talent and handled the contracts and payments for them. He ran the Tom Gubbins Asiatic Costume Company on Los Angeles Street and spoke fluent Cantonese. Chan appeared in *Samurai, The Mysterious Mr. Wong*, and more.

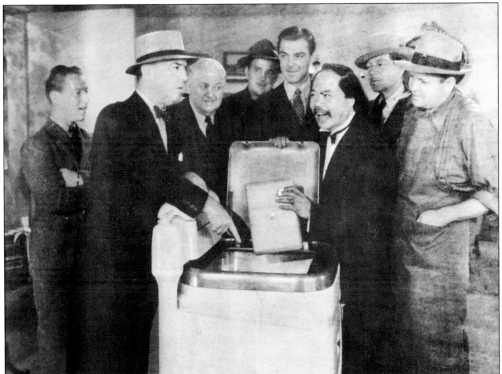

Willie Fung (c. 1896–1945), third from left, was a prolific actor who created a space for himself to express his energetic comedic talents despite being routinely cast in stereotypical roles as servants or cooks. While working as a peanut vendor in San Francisco, Fung was discovered by a producer scouting for *Hurricane's Gal* (1922). At one point, he ran a restaurant/saloon at Sunset and Hollywood Boulevards that was fondly described in author Henry Miller's *Remember to Remember* (1947).

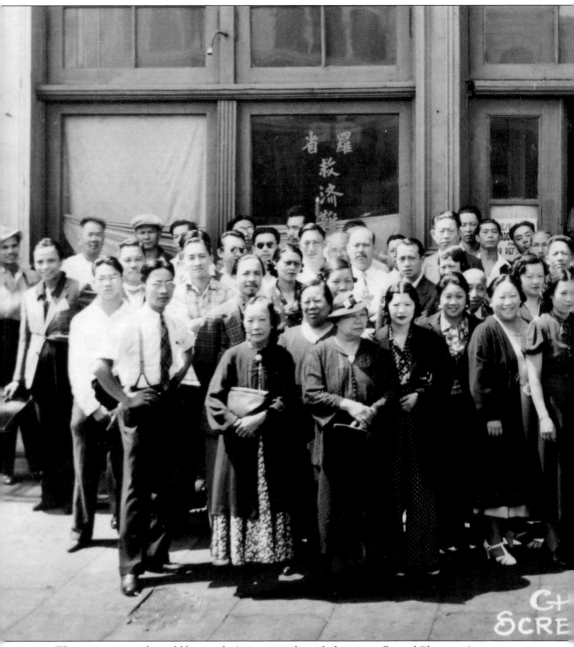

The growing number of films with Asian story lines led to an influx of Chinese American actors in the Screen Actors Guild. Chinese members of the Screen Actors Guild posed for this group

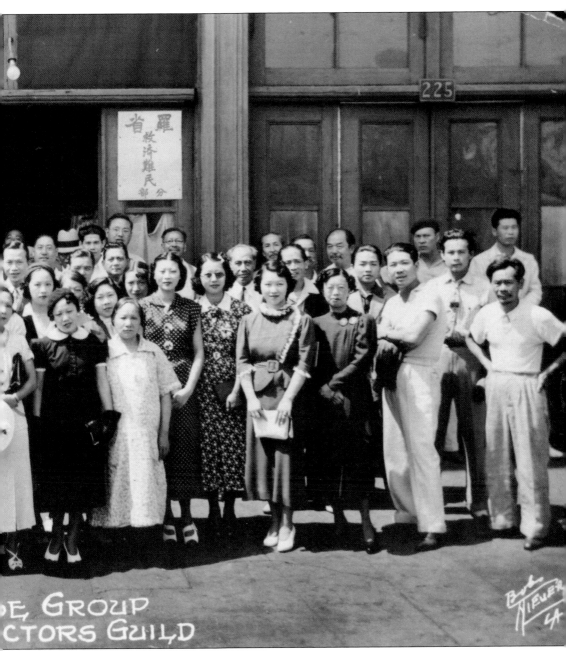

省羅

救济難民

部分

225

E GROUP
CTORS GUILD

Bob
NIEMER
LA

photograph around the late 1930s.

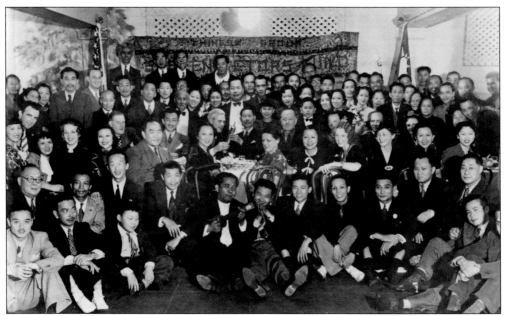

In 1937, the Chinese group of the Screen Actors Guild (SAG) won first prize for the "most beautiful float, the largest group, and the most colorful contingent" in the Los Angeles Labor Day parade. Larry Steers, president of the Screen Actors Guild Junior Guild, holds the trophy donated by the Retail Shoe Salesmen's Union. Bessie Loo sits in front of Steers; her former husband, actor Richard Loo, sits diagonally left of her. SAG executive Pat Somerset (in checkered tie) is left of Loo. Jennie Chan Lee is second from right at the table, and behind the table is actor Barbara Jean Wong Lee. Homer Yip, owner of Cathay Shop in China City, stands in front of the American flag. His son, Sinclair Yip, was an extra in *The Good Earth*. (Courtesy of Donna Carrell.)

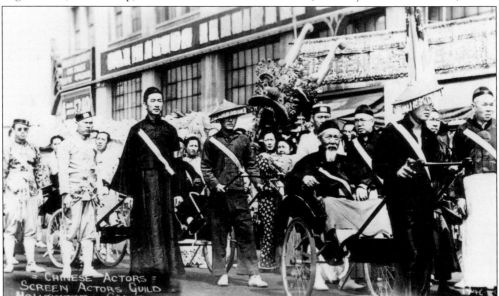

Chinese members of the Screen Actors Guild marched in the Los Angeles Labor Day parade near the Los Angeles Coliseum, formerly known as the Hollywood Coliseum, around 1937. (Courtesy of the Los Angeles Public Library Photo Collection.)

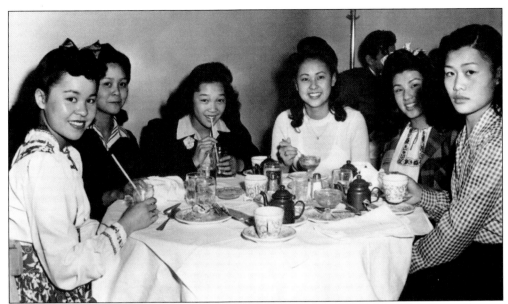

Pictured here are, from left to right, Barbara Jean Wong Lee, Lorelei Quon, Betty Quon, Frances Chan, Doris Chan, and Doris Young. The young ladies, who appeared together in *China* (1943), dine together in a commissary at Paramount Studios. Sisters Lorelei and Betty Quon's family were pioneers in Los Angeles Chinatown; their grandfather Soon Doon Quon opened one of the first Chinese restaurants in Los Angeles—Tuey Far Low—and, along with the girls' father, Him Gin Quon, became a founding member of New Chinatown. (Courtesy of Universal Studios Licensing, LLC; physical photograph courtesy of Soft Film.)

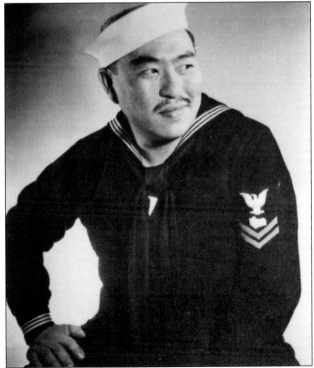

Chester Gan made his debut in *Shanghai Express* (1932) and worked prolifically through 1943, making nearly 100 films. Like many Chinese American character actors, he played his share of cooks, waiters, and— during World War II—Japanese villains, but Gan also served as interpreter on *Blood Alley* (1955) and was hired by MGM to teach Paul Muni how to act Chinese in *The Good Earth*.

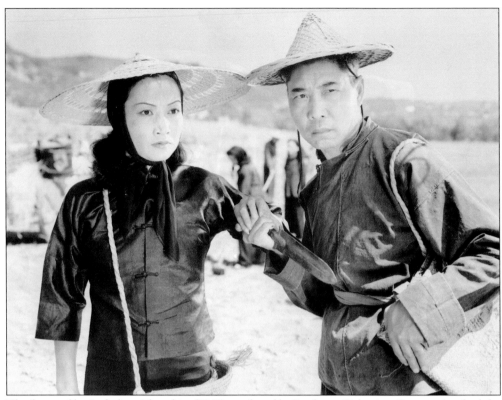

The feature film *Lady from Chungking* (1942), produced by Producers Releasing Corporation, had the distinction of casting two Chinese American actors—Anna May Wong and James B. Leong—in leading roles. The pair had previously worked on *The Silk Bouquet* (1926) with Grandview Film Company cofounder Joseph Sunn Jue. In *Lady from Chungking*, Wong portrayed the noblewoman and guerrilla leader Kwan Mei, who infiltrates the tyrannical Japanese forces in China and kills their leader, General Kaimura. Leong, an actor and filmmaker, played a peasant guerrilla fighter and Wong's ally. (Courtesy of Soft Film.)

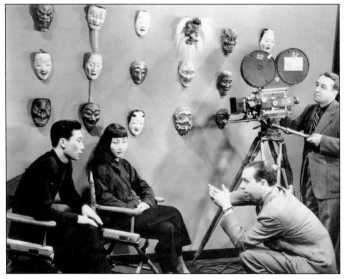

Robert Florey directs Anna May Wong and Philip Ahn in *Daughter of Shanghai*. Wong was excited to costar in a film with an Asian American male lead. Ahn, a pioneering Korean American actor, played a detective who solves a murder case and then asks Wong's character to marry him. This gave the film a special edge, as romantic scenes between two Asian American actors were rare at the time. (Courtesy of Universal Studios Licensing, LLC.)

In *Bombs Over Burma* (1942), Anna May Wong plays a schoolteacher who thwarts an Axis plot to sabotage the Allies during World War II. Wong speaks Chinese and English in the film. Here, she stands behind Hayward SooHoo, who played a troublemaking student who later gets killed during the war. (Courtesy of Hayward SooHoo.)

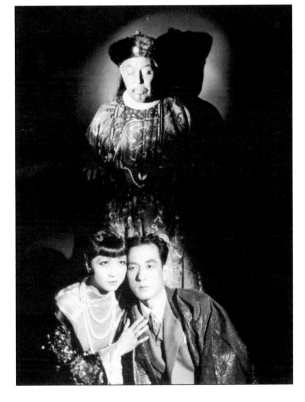

Anna May Wong and Sessue Hayakawa costarred in *Daughter of the Dragon* (1931). They had previously appeared together in *The First Born* (1921) at a time when Hayakawa was the highest-profile Asian actor working in Hollywood and Wong was in the early stages of her career. Warner Oland (top) played the devious Fu Manchu, a symbol of Hollywood's Yellow Peril stereotype of Asian characters. (Courtesy of Universal Studios Licensing, LLC.)

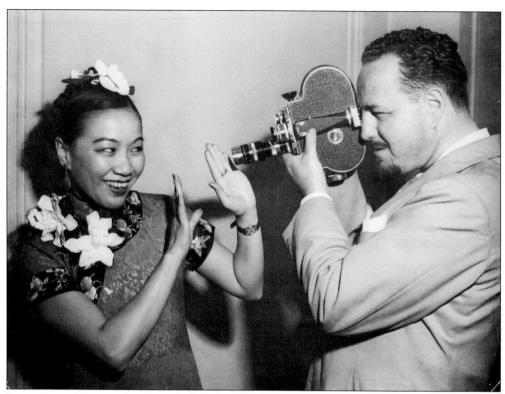

Journalist and director Rey Scott (right) playfully shoots Li Ling-Ai with a camera. Hawaiian-born Li's parents encouraged her creativity and inspired her to speak her mind. To raise awareness about China's plight during World War II, Li recruited Scott to direct the documentary *Kukan* (1941). Although Li performed all the functions of a producer, she only received a credit of technical advisor on the film. *Kukan* became the first documentary to win an Academy Award, which was awarded to Scott. (Courtesy of the Scott family.)

In 1944, forty Chinese aviation cadets were treated to a day of entertainment at Pickfair, the estate of Mary Pickford. The cadets, who had been training at Santa Ana Army Air Base, received a warm reception from Pickford and Chinese USO junior hostesses. Pictured here are, from left to right, Cadet Chiang Wei Hwa, Anna Lee, Mary Pickford, Cadet Hu Ming Tau, Barbara Jean Wong Lee, May Lee Wong, and Cadet Lu Sheng Lin. (Courtesy of the Los Angeles Times Photographic Archive, Department of Special Collections, Charles E. Young Research Library, UCLA.)

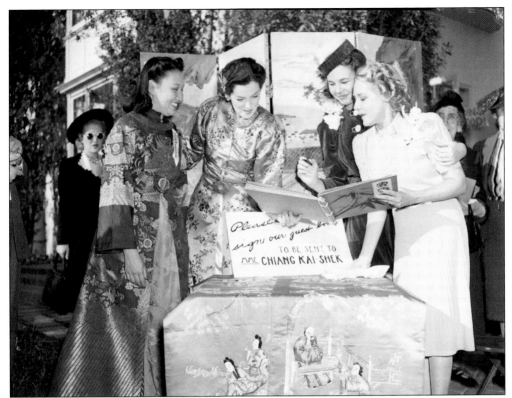

In 1940, actor and pilot Lee Ya-ching (1912–1998) attended a Los Angeles charity event for Chinese war orphans. The guest register was to be sent to Madame Chiang Kai-Shek. In this photograph are, from left to right, Lee Ya-ching, Rosalind Russell, Jane Withers, and Mary Pickford. Lee Ya-Ching had a successful film career in Shanghai during the 1920s with productions such as *Hua Mulan Joins the Army* (1928). (Courtesy of the Los Angeles Times Photographic Archive, Department of Special Collections, Charles E. Young Research Library, UCLA.)

Lee Ya-Ching stands in front of her Stinson Reliant SR-9B, the *Spirit of New China*. She became the first woman to receive a government pilot's license in China and used her flying skills to raise funds for China's war-relief effort. She tried to enlist in the Chinese air force, but much to her disappointment, her offer was rejected. (Courtesy of National Air and Space Museum, NASM 9A06065.)

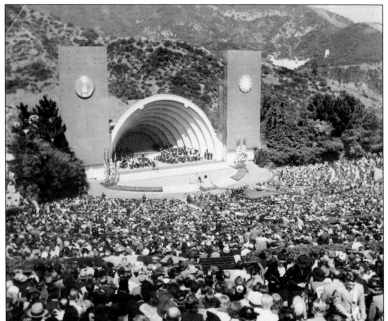

A packed audience of dignitaries, celebrities, Chinese Americans, and general spectators flocked to the Hollywood Bowl on April 4, 1943, to listen to Madame Chiang Kai-Shek's speech. The event was produced by movie mogul David O. Selznick and attended by approximately 30,000 people. (Courtesy of the Peter SooHoo Sr. Collection.)

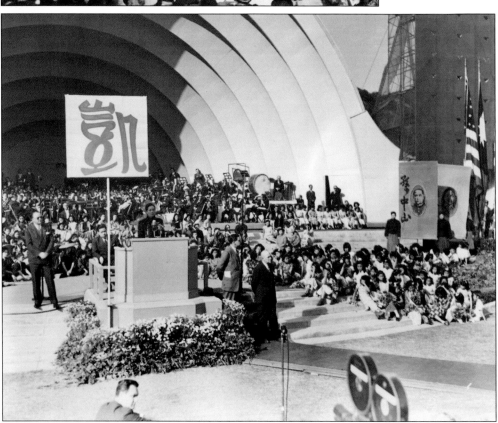

This photograph shows a view of the Hollywood Bowl stage where Madame Chiang Kai-Shek made a historic speech in 1943. (Courtesy of the Los Angeles Public Library Photo Collection.)

Madame Chiang Kai-Shek (also known as Mayling Soong or Soong May-ling) was one of the most powerful Chinese women in the 20th century. Her family influenced the course of China's history: her father helped finance the Chinese revolution; her middle sister married Sun Yat-Sen; her eldest sister became wife of China's wealthiest man and finance minister. As wife of Generalissimo Chiang Kai-Shek, she traveled around the world to raise support for China during World War II. In 1943, she gave a speech at the Hollywood Bowl that described the horrors of the Japanese invasion of China. (Right, courtesy of the Peter SooHoo Sr. Collection; below, courtesy of the Los Angeles Public Library Photo Collection.)

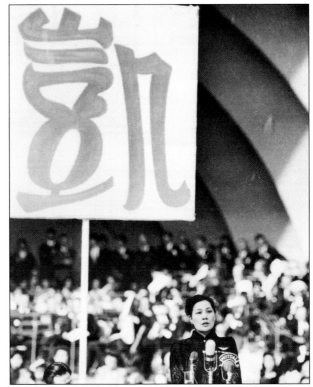

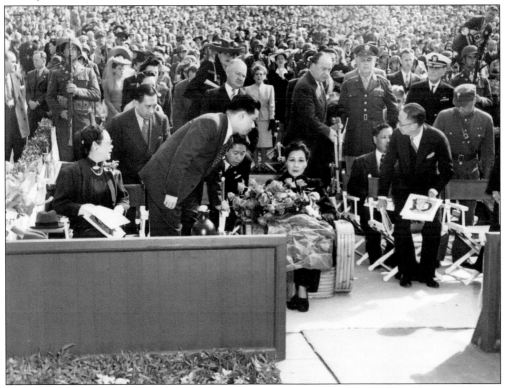

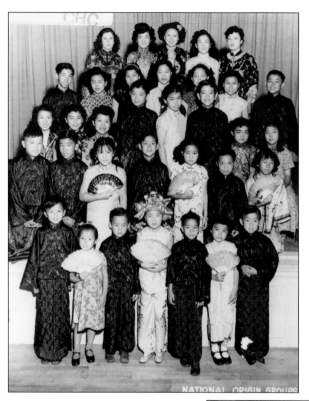

Chinese American children participated in the National Origins Groups Pageant at the Hollywood Bowl in honor of Madame Chiang Kai-Shek's 1943 visit to Los Angeles.

An enthusiastic audience of approximately 30,000 enters the Hollywood Bowl to hear Madame Chiang Kai-Shek's speech in 1943. The two pins at bottom identify Peter SooHoo Sr. and Lillie SooHoo, a prominent couple in the history of Los Angeles Chinatown. Peter SooHoo Sr. was a cofounder of New Chinatown, and his wife was Chinese Consulate secretary in Los Angeles. The couple helped facilitate Madame Chiang Kai-Shek's visit. (Bottom portion of photograph courtesy of the Peter SooHoo Sr. Collection.)

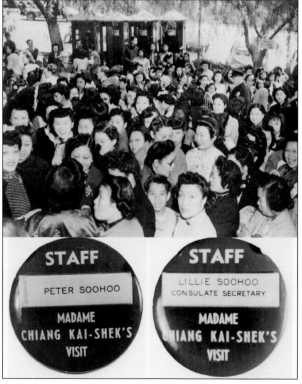

Donald Chu (1916–2007) was the first Chinese American editor accepted into the Motion Picture Editors Guild Local No. 776. Born in China, Chu immigrated to the United States with his family and settled in Manhattan's Chinatown. During World War II, he was assigned to a civilian position editing war films after his hearing ailment exempted him from the draft. Later, he moved to Los Angeles and began working as an assistant editor and then editor for several years. His credits include *Love, American Style*, *Sky Riders*, and *Catastrophe*. (Courtesy of Kit-Lan Chu.)

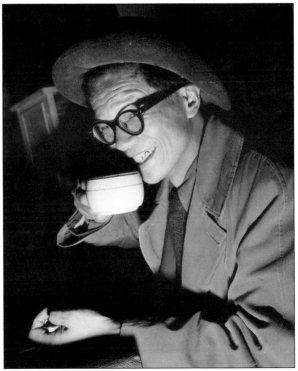

Hsi Tseng Tsiang (1899–1971), known as H.T. Tsiang, expressed himself through poetry, plays, novels, performance, producing, and activism. Born in China, Tsiang moved to New York City to study at Columbia University. During his detainment at Ellis Island, he wrote letters to Rockwell Kent that intimated a physical attraction toward the artist. Nicknamed the "Chinese Orson Welles," Tsiang presented himself like a bohemian. He produced several one-man shows and theatrical performances, including a presentation from his novel *The Hanging on Union Square*. His acting credits include *The Keys of the Kingdom*, *Panic in the Streets*, *Bachelor Father*, and *Bonanza*. (Courtesy of Soft Film.)

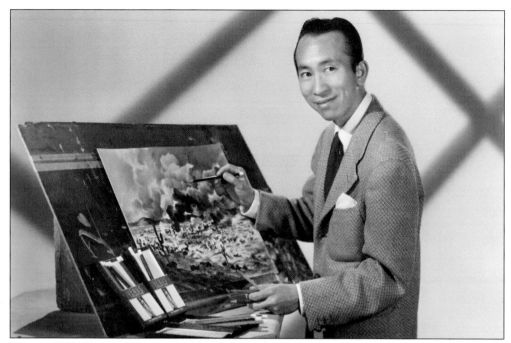

Born in 1910, Tyrus Wong emigrated with his father from Canton, China, to the United States and became one of the first Chinese Americans to work at Disney. As a child, he was detained at Angel Island en route to San Francisco. He lived with his father on Ferguson Alley in Old Chinatown Los Angeles and earned a scholarship to Otis Art Institute. Wong was hired by Walt Disney Studios to work as an in-betweener on projects such as Mickey Mouse short films. The in-betweener creates drawings that illustrate motion between the main poses of a character. The job's monotony frustrated Wong, so he created background art for consideration on *Bambi*. His atmospheric forest scenes got him hired on the film as an inspirational sketch artist, and he was later named a Disney Legend for his work at the studio. Above, Wong poses for an advertisement for Venus Pencils. Below, he illustrates the out-of-print magazine *Warner News*. He is the subject of Pamela Tom's documentary *Brushstrokes in Hollywood*. (Both, courtesy of Tyrus Wong.)

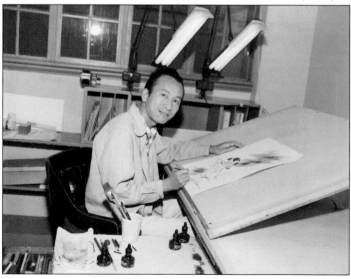

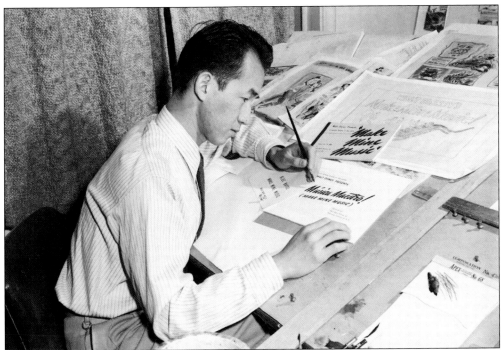

Here, artist Milton Quon draws at his drafting table at Walt Disney Studios. He is doing brush lettering for the Spanish title of *Make Mine Music*. Quon, one of the first Chinese Americans to be hired by Disney, worked on films such as *Dumbo* and *Fantasia*. During World War II, he was recruited to illustrate manuals for Douglas Aircraft. He became the first Chinese American art director at the advertising firm BBDO. At age 99, he was honored with a 2013 Golden Spike Award by CHSSC. (Both, courtesy of © Disney.)

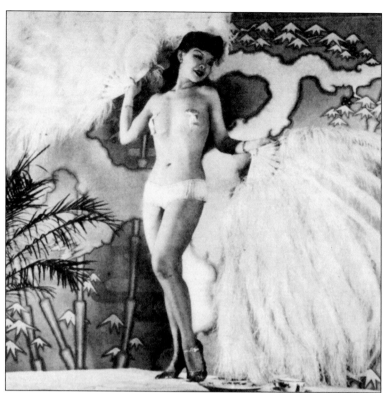

One of the star attractions at the legendary Forbidden City nightclub, burlesque dancer Noel Toy was known as the "Chinese Sally Rand." In 1945, she stopped performing after her marriage to actor Carleton Young, but she worked occasionally, with appearances in *Soldier of Fortune*, *M*A*S*H*, and *Big Trouble in Little China*. (Courtesy of Soft Film.)

Detroit-born Gloria Chin was rechristened Maylia and recognized as "Hollywood's first Chinese starlet since Anna May Wong." After appearing in films such as *To the Ends of the Earth* (1948) and *Boston Blackie's Chinese Venture*, she retired from acting to start a family with actor Benson Fong. She helped Fong run their family restaurant chain, Ah Fong's. (Courtesy of Soft Film.)

# *Three*

# GOTTA DANCE AND SING

Based on the novel by C.Y. Lee, *Flower Drum Song* is a Broadway musical and film that introduced audiences to a new generation of Asian American talent. Brought to the stage by Richard Rodgers and Oscar Hammerstein II, the musical was nominated for six Tony Awards and won one. The film received five Academy Award nominations. With choreographer Hermes Pan, Nancy Kwan (center) and the cast rehearsed for several weeks on a Universal Studios lot that replicated Grant Avenue in San Francisco's Chinatown. During one of the rehearsals, acting and dancing legend Fred Astaire visited the set and met Nancy Kwan. (Courtesy of Rodgers & Hammerstein: An Imagem Company.)

In this scene from *Flower Drum Song*, Nancy Kwan (center) performs "Fan Tan Fannie" at the Celestial Bar, which employed her character as a singer. Directed by Henry Koster from a script written by Joseph Fields, *Flower Drum Song* was the first mainstream musical film to feature a mostly Asian American cast. (Courtesy of Rodgers & Hammerstein: An Imagem Company.)

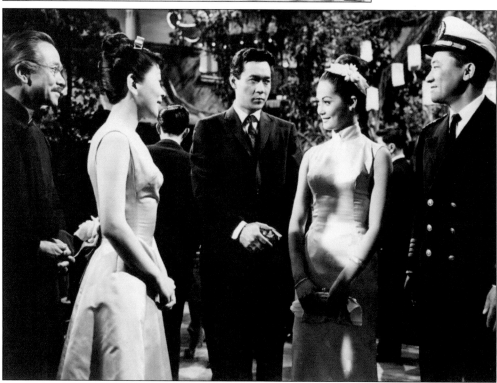

Starring in *Flower Drum Song* are, from left to right, Kam Tong, Miyoshi Umeki, James Shigeta, Nancy Kwan, and Victor Sen Yung. Shigeta and Kwan later starred in the play *Love Letters*. (Courtesy of Rodgers & Hammerstein: An Imagem Company.)

Pictured here are James Shigeta (left), Benson Fong (center) and Juanita Hall. Hall was an African American actor cast as Auntie Liang. She and Fong sing the duet "Chop Suey," a song about assimilation. (Courtesy of Rodgers & Hammerstein: An Imagem Company.)

*Flower Drum Song* addressed the generational and cultural conflicts between immigrant Chinese parents and their American-born children. Here, sisters Cherylene Lee (left) and Virginia Lee (center) sing "The Other Generation" with Filipino American actor Patrick Adiarte. Born in Los Angeles, Cherylene Lee is an actor and playwright whose works include *The Legacy Codes*, a play about the scientist Wen Ho Lee. The siblings appeared on *The Dinah Shore Show* and performed in Las Vegas as "the Lee sisters." (Courtesy of Rodgers & Hammerstein: An Imagem Company.)

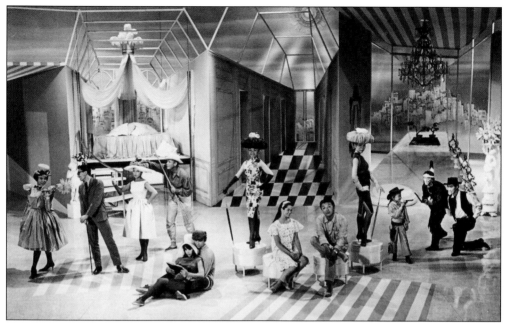

This photograph shows the stylized set for the song "Sunday," in which characters Linda Low and Sammy Fong sing about their future married life. Seated together, Nancy Kwan and Jack Soo launch into this imaginary sequence after their characters agree to marry. Soo was a Japanese American actor who changed his surname to avoid persecution during World War II. (Courtesy of Rodgers & Hammerstein: An Imagem Company.)

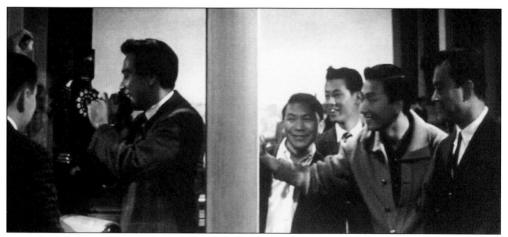

Played by James Shigeta, Wang Ta calls Linda Low in a phone booth as his friends watch excitedly in a scene from *Flower Drum Song*. Fourth from right is Guy Lee, an actor and casting agent who represented Asian American actors as principal of Guy Lee & Associates Agency. Lee was a child vaudeville performer and actor with credits including *The Keys of the Kingdom* and *Blue Hawaii*. He was also a cofounder of East West Players. (Courtesy of Rodgers & Hammerstein: An Imagem Company.)

Here, Nancy Kwan (right) and Esther Lee Johnson (left) take a break from filming. Johnson was a stand-in for Miyoshi Umeki and Nancy Kwan and also played a bar girl who dated Willie SooHoo's character in *Flower Drum Song*. Born in Seattle, she moved with her family to Los Angeles. She met casting agent Tom Gubbins, who put her in *The Good Earth* (1937). She appeared in *The Keys of the Kingdom*, *Planet of the Apes*, *The King and I*, and *Blood Alley* and was also represented by Bessie Loo. (Courtesy of Esther Lee Johnson.)

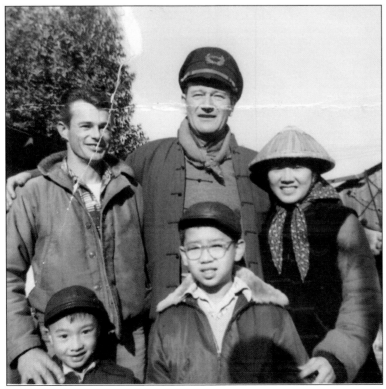

John Wayne smiles with Esther Lee Johnson (right) and her husband, Dan Johnson (left), during a break from shooting *Blood Alley* (1955). The film tells the story of a merchant marine captain who is compelled to transport Chinese refugees to Hong Kong. Johnson played a Chinese villager in the film. (Courtesy of Esther Lee Johnson.)

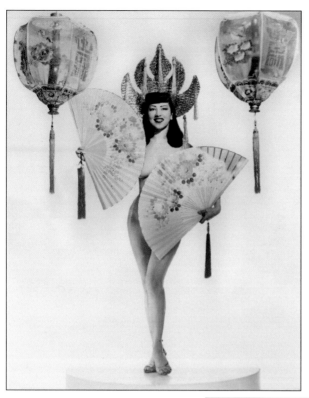

In 2011, Barbara Yung received the Legend of Burlesque Award from the Burlesque Hall of Fame. Born in Oakland in 1919, Yung trained to be a dancer at the San Francisco Ballet. She appeared in the film *Pal Joey*, starring Frank Sinatra, and performed at several nightclubs across the country. (Courtesy of Shanghai Pearl.)

Born in Stockton, California, Jadin Wong (1913–2010) had several careers during her lifetime. After high school, she ventured to Hollywood and was cast in a few Charlie Chan and Mr. Moto films. But the work was not enough, so she pursued dance training at the San Francisco Opera Ballet. While dancing at Forbidden City in San Francisco, she appeared in *Life* magazine, which brought her international recognition. She moved to New York City, danced at China Doll, and later performed for American troops stationed in Europe. After trying her hand at comedy, she launched a successful business as a talent manager in New York City, representing a bevy of Asian American actors. (Courtesy of Arthur Dong, Forbidden City, U.S.A. Collection.)

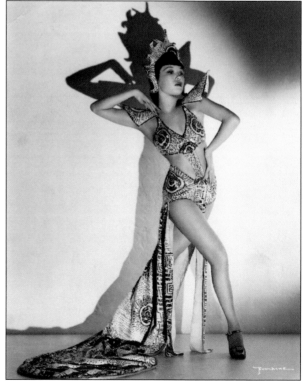

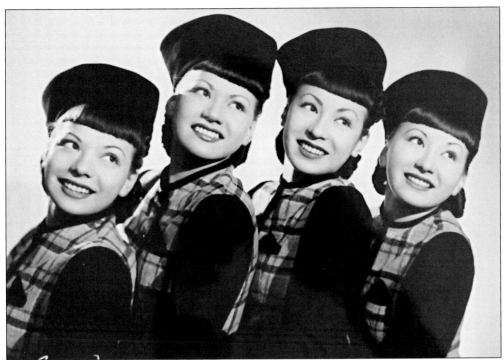

Known as the "Chinese Andrews Sisters," the Kim Loo Sisters were a jazz vocal quartet that delighted audiences in Minneapolis kid revues, vaudeville stages, Hollywood movies such as *Meet Miss Bobby Socks* (1944), and as part of the USO on tour during World War II. The "Kimmies" are, from left to right, Alice, Maggie, Jenée, and Bubbles Loo. They are the subject of Leslie Li's documentary, *The Kim Loo Sisters*. (Photograph by James Kriegsmann, courtesy of Leslie Li.)

Born in Oakland, Mai Tai Sing trained with Walton Biggerstaff, a choreographer for Forbidden City nightclub in San Francisco. While working as a waitress at Forbidden City, she met the dancing duo of Wilbur and Jessie Tai Sing. She replaced Jessie Tai Sing and toured the country with Wilbur Tai Sing (pictured), who became her husband and father to her two children. She appeared in the television series *Hong Kong* and hosted viewings of Charlie Chan films on channel 44. (Photograph by Romaine, courtesy of Soft Film.)

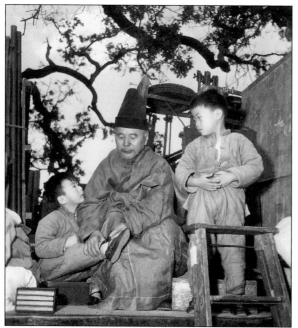

Daniel "Danny" P.Y. Chang (left) played a Chinese orphan who is saved by Ronald Reagan's character, Jeff, in Hong Kong (1952). At age four, Chang was brought to a casting call by his father, John Wen Ti Chang (center), who also appeared in the film. Chang eventually left show business and enrolled in Caltech to study mechanical engineering. He became a professor at the University of California, Davis, where he served as vice-chair of the Department of Civil and Environmental Engineering. (Courtesy of Paramount Pictures. HONG KONG © Paramount Pictures Corporation. All Rights Reserved.)

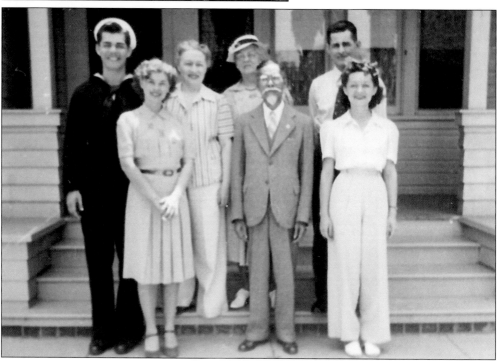

Actor Moy (Luke) Ming lived at 5936 Carlton Way in Hollywood. He met his wife, Annie Ming, at a Baptist church where she taught Sunday school. They got married in Illinois, a state that allowed Asians to marry non-Asians at the time. In this photograph are, from left to right, (first row) Frances Virginia Greenaway (granddaughter-in-law), Ming, and Virginia Mae Ming (granddaughter); (second row) Donald Lewis Ming (grandson), Florence Camille Ming (daughter-in-law), Annie Ming (wife), and Clarence Donald Moy Ming (son). (Courtesy of Donna Carrell.)

Walter SooHoo and his family were extras in *Around the World in 80 Days*. Seen here are, from left to right, his friend James Louie, brother Hayward SooHoo, mother Woo Shee SooHoo, Walter himself, and wife Eileen SooHoo. Walter and Eileen are the owners of Phoenix Imports and Hop Louie Restaurant in Los Angeles Chinatown's Central Plaza. (Courtesy of Walter SooHoo.)

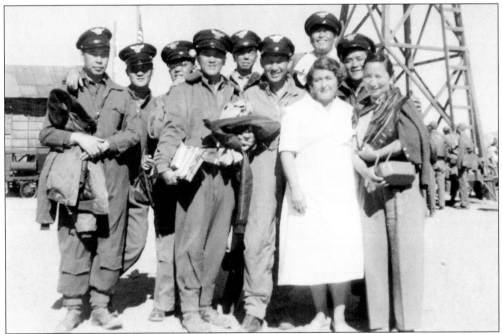

Brothers Walter and Willie SooHoo take a break from filming *Battle Hymn* in Mexico. Pictured from left to right are unidentified, Walter SooHoo, Paul King, and Owen Song. Second from right is Willie SooHoo. Their father, She Wing SooHoo, was one of the founding members of New Chinatown after Old Chinatown was torn down to build Union Station. (Courtesy of Walter SooHoo.)

Pictured here is Jane Chung (1911–2012) from *Teahouse of the August Moon*. She was raised in the all-Chinese enclave of Locke, California. After getting married and having two children, Chung started working as an extra and was later cast in speaking roles. In *When Harry Met Sally*, Chung was the wife of the Chinese interviewee. Her other credits include *Around the World in 80 Days*, *Chinatown*, and *The Birds*, among others. She is the subject of the documentary *More Than a Face in the Crowd*, directed by her grandniece Sami Chan and coproduced by her daughter Sue Fawn Chung. (Courtesy of Jane Chung.)

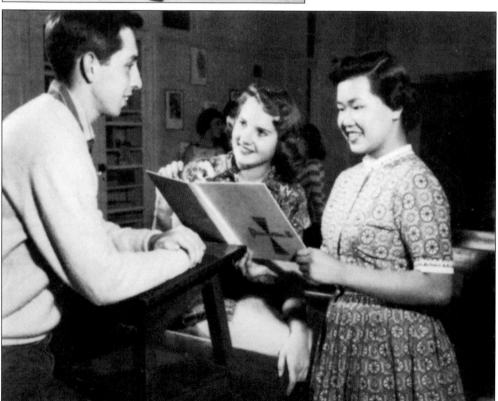

Lenore Wong was on the yearbook committee at Hollywood High School in 1956. At the time, Chinese and Chinese American students were a small minority at the school, but the demographic has slowly grown over the decades.

As Miss Hong Kong, Judy Dan was third runner-up in the 1952 Miss Universe pageant in Long Beach, California. She settled in Hollywood to pursue an acting career. Here, she explains the intricacies of chopsticks to David and Ricky Nelson in the episode "The Loan" from *The Adventures of Ozzie and Harriet* in 1957. (Courtesy of © American Broadcasting Companies, Inc.)

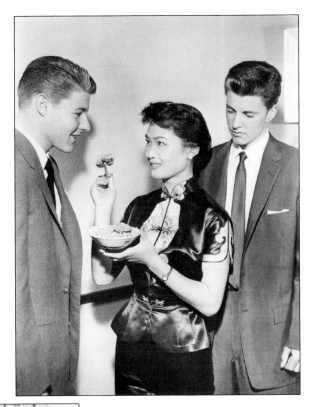

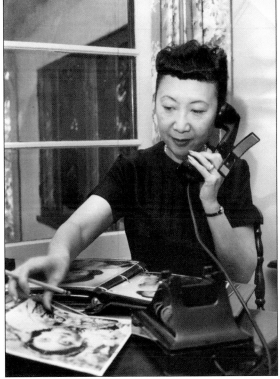

Originally from Hanford, California, Bessie Loo was a talent agent who represented several generations of Asian American actors. She appeared in *The Good Earth* and was recruited by Central Casting to help fill calls for Asian background players. While raising her twins, she began casting Asian extras out of her home. Fearless, tenacious, strong-willed, and persevering, Loo became principal of her own company, the Bessie Loo Agency, at a time when it was rare to be a Chinese female business owner. Upon her retirement, her agency was taken over by her business partner, actor Guy Lee. Pictured here at her desk in 1958, Loo views a headshot of actor Lisa Lu. (Courtesy of Soft Film.)

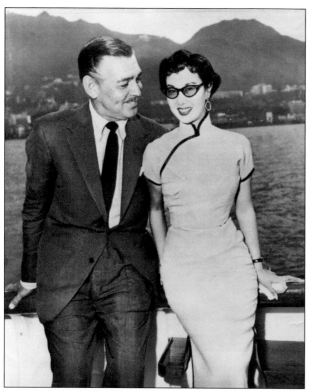

During Clark Gable's visit to Hong Kong in 1954 to film *Soldier of Fortune*, he took a break to meet Li Li-Hua, the legendary Mandarin movie queen who ruled the screen from her successful 1939 debut in pre-Communist Shanghai until her retirement and immigration to the United States in the 1970s. They are pictured here on a cruise around Hong Kong Island. (Courtesy of AP Photo.)

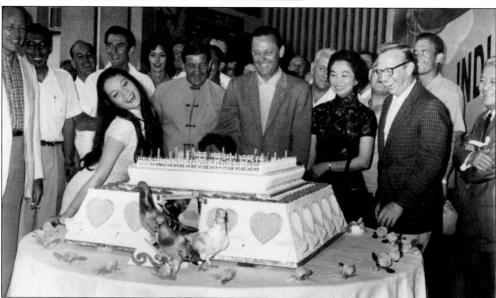

Nancy Kwan was surprised with a birthday cake on the set of *The World of Suzie Wong* (1960) in Hong Kong. This photograph was taken in between the shooting of the ferry scene from Hong Kong to Kowloon. At center stands costar William Holden, and to the right of him are, from left to right, Nancy's stepmother, Nan Kwan; Ray Stark; and Nancy's father, Kwan Wing Hong. (Courtesy of Paramount Pictures. THE WORLD OF SUZIE WONG © Paramount Pictures Corp. All Rights Reserved.)

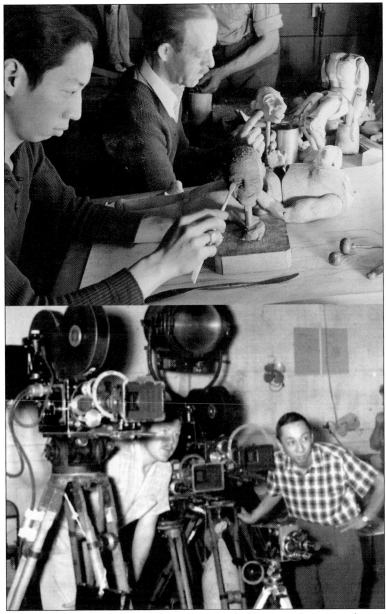

Wah Ming Chang (1917–2003) was a pioneer in visual effects, sculpture, and prop design. He and his family moved from Honolulu to San Francisco, where he was invited to exhibit his art at just nine years old. After his mother's death, he moved to Los Angeles to live with his mentor, Blanding Sloan, and began working on film sets. He was hired by Disney to create maquettes and models for *Bambi* and *Pinocchio* but left after being stricken with polio. As cofounder of Project Unlimited, Inc., he worked on *The Time Machine* (1960), which won an Academy Award for its special effects. He is best known for his work on *Star Trek*, for which he designed the tricorder and the communicator, considered an early influence on the flip mobile phone design. In the top photograph, Chang sculpts a head for *The Lost Island*, a King Kong parody featuring marionettes of the Marx Brothers and Mae West. The bottom photograph shows Chang and Gene Warren Sr. shooting the lava flow for *The Time Machine*. (Courtesy of the Estate of Wah Ming Chang.)

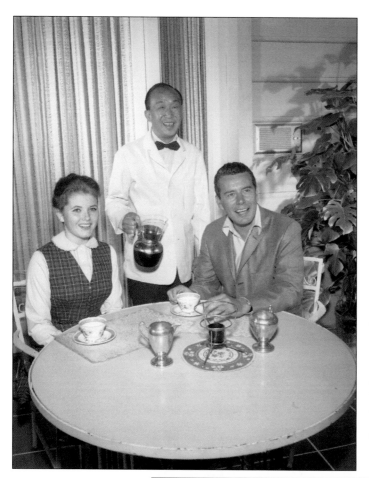

In 1959, Sammee Tong was called one of the "funniest men to wield a pair of chopsticks" by the *Los Angeles Times*. While performing live comedy, Tong was discovered by a talent scout and cast in *Happiness Ahead* (1934), which also featured Dorothy Toy and Paul Wing. Pictured here with Noreen Corcoran (left) and John Forsythe (right), Tong played Peter in *Bachelor Father*, one of the first television shows to feature a Chinese American series regular. While cast on *Mickey*, Tong overdosed on pills and died in his Palms apartment in 1964. (Courtesy of © American Broadcasting Companies, Inc./ ABC Photo Archives/ Disney ABC Television Group/Getty Images.)

Born in Honolulu, Kam Fong Chun (1918–2002) starred as Chin Ho Kelly on the CBS show *Hawaii Five-O*. Fong's early life was beset by tragedies. His brother died in an accidental fire, and his first wife and two of his children were killed after two B-24 bombers crashed over the family home during World War II. Fong became a police officer in Hawaii before being cast by CBS for what would become a 10-year run on *Hawaii Five-O*. (Courtesy of CBS/Landov.)

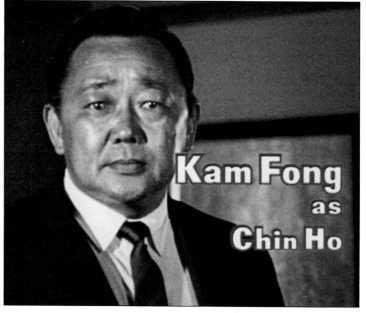

James Wong Howe sits behind a camera on the outdoor set of *Hud* (1963). Howe won his second Academy Award for Cinematography for this film. His artistry with lighting, shadow, and composition made him popular among actors, who requested him for his ability to enhance their best features. (Courtesy of Paramount Pictures. HUD © Paramount Pictures, Salem Productions, Inc., and Dover Productions, Inc. All Rights Reserved.)

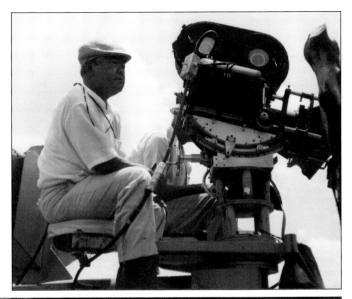

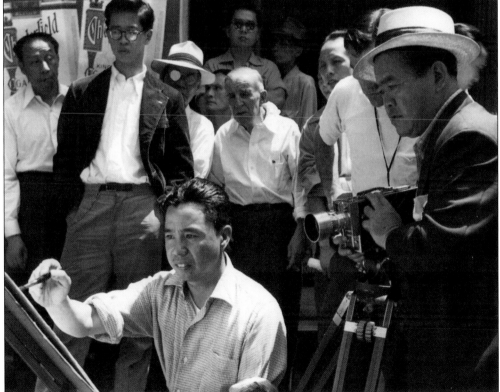

James Wong Howe (right) directed the documentary *The World of Dong Kingman*. Dong Kingman (seated) was a celebrated watercolorist and production artist for several films. He illustrated the main credit titles for *Flower Drum Song* and worked on *The World of Suzie Wong*, *Lost Horizons*, and more. His art is in over 50 permanent collections, including the Museum of Modern Art and Metropolitan Museum of Art. (Photograph from the collections of the Margaret Herrick Library; courtesy of Don Lee and the James Wong Howe Estate.)

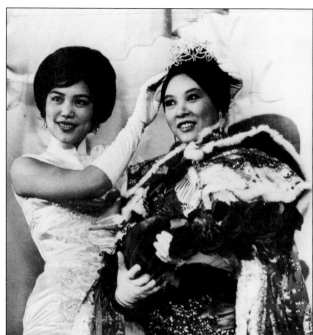

Born in Shanghai, Irene Tsu got her start in the Broadway run and national tour of *The World of Suzie Wong*. In 1961, she was named Miss Chinatown USA, and she is shown here being crowned by previous queen Carol Ng. Tsu's career spans more than 50 years and includes *The Green Berets* (1968), the award-winning Hong Kong film *Comrades: Almost a Love Story* (1996), and *Cold Case* with Jack Ong. (Courtesy of UPI Telephoto, physical photograph courtesy of Soft Film.)

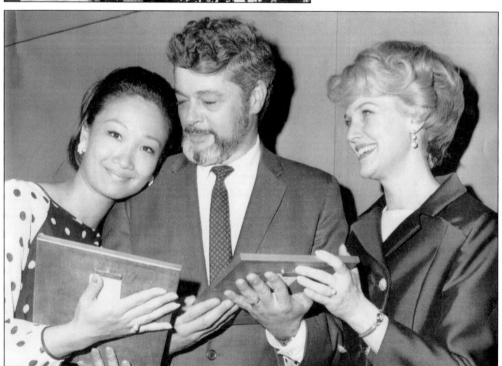

Actor Tina Chen (left), daughter of a Nationalist Chinese general, and director Paul Bogart smile as Barbara Britton presents them with Emmy nomination plaques in this photograph dated May 10, 1967. Chen and Bogart were nominated for the television movie *The War of Olly Winter*, which premiered on CBS Playhouse. Chen also appeared in *Alice's Restaurant* (1969) and was nominated for a Golden Globe for *The Hawaiians* (1970). (Courtesy of UPI Telephoto.)

A child prodigy, Virginia "Ginny" Tiu was invited to play piano on *The Ed Sullivan Show* at age five. She performed for Pres. John F. Kennedy and appeared in the film *Girls, Girls, Girls* with Elvis Presley and her siblings. Pictured here on their album cover, the Ginny Tiu Revue (featuring siblings Ginny, Vicky, Elizabeth, and Alexander Tiu) can be considered one of the first Asian American pop bands. (Courtesy of Sony Music Entertainment.)

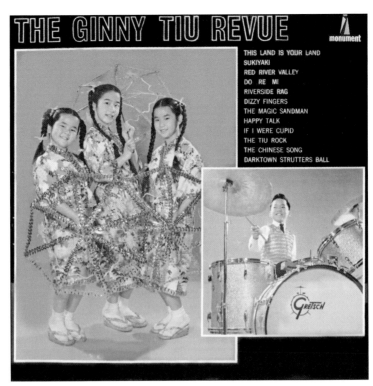

Esther Wong (left), Alan Yee (center), and Alan Yee's mother, Cathy Wong Yee, are pictured at their home in Hollywood around 1968. Sisters Esther and Cathy ran Madame Wong's nightclub in Los Angeles Chinatown. In its heyday, Madame Wong's featured performances by the Police, Oingo Boingo, the Motels, and other up-and-coming bands. As an adult, Alan Yee managed Madame Wong's West in Santa Monica. (Courtesy of Melinda Holland.)

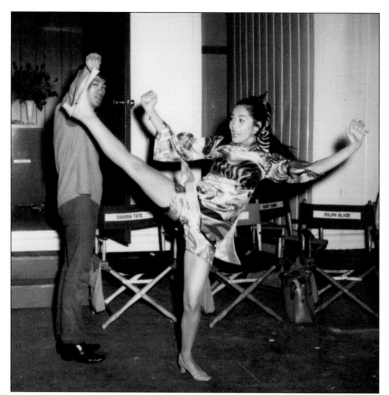

Nancy Kwan practices a kick with Bruce Lee, who worked as stunt advisor on the spy film *The Wrecking Crew* (1968). ("THE WRECKING CREW" © 1968, 1996 Columbia Pictures Industries, Inc. All Rights Reserved. Courtesy of Columbia Pictures.)

Beijing-born Lucille Soong worked as a fashion model and actress in London during the 1960s. In 1969, she played the first Chinese character in the television series *Coronation Street*. Pictured here in 1959, she appeared in *Ferry to Hong Kong* with Orson Welles and Curt Jurgen. Her later credits include *The Joy Luck Club*, *Freaky Friday*, and *Desperate Housewives*. (Courtesy of © Press Association.)

# *Four*

# NEW GENERATIONS

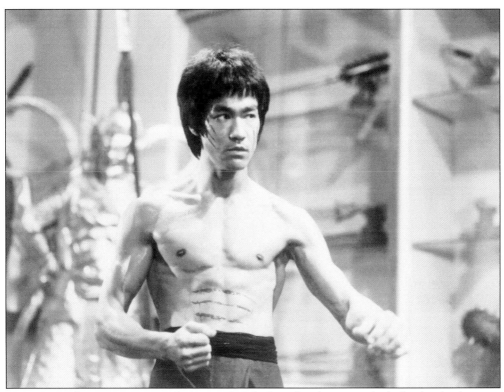

Bruce Lee strikes a pose in *Enter the Dragon* (1973). Completed just months before his death, it was added to the National Film Registry in 2004. The son of Cantonese opera star Lee Hoi-Chuen, Lee was born in San Francisco and made his film debut as an infant in Esther Eng's *Golden Gate Girl* (1941). After moving back to Hong Kong with his family, he starred in such films as *The Kid* (1950) and *The Orphan* (1960). Lee made his American debut in the television series *The Green Hornet* (1966–1967) but became frustrated by the lack of opportunities in Hollywood. He returned to Hong Kong, where he achieved success on his terms and revolutionized action movies. He was instrumental in establishing martial arts films as a genre. Lee's premature death on the verge of superstardom has immortalized him as one of the most iconic figures of the 20th century. (Licensed by: Warner Bros. Entertainment Inc. All Rights Reserved.)

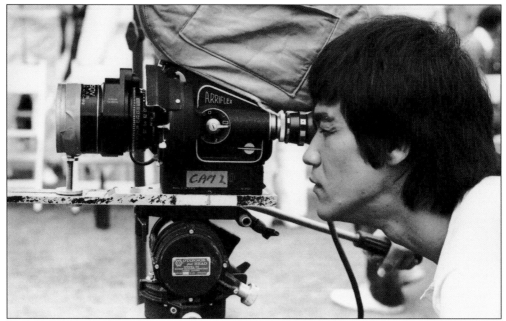

Bruce Lee is pictured here on the set of *Enter the Dragon*, which celebrated its 40th anniversary in 2013. The photograph underscores Lee's interest in filmmaking and his interest in telling stories with strong Asian leading characters. He formed a production company with producer Raymond Chow and wrote, directed, and starred in *The Way of the Dragon* (*Return of the Dragon*), featuring Chuck Norris. Lee left behind an indelible legacy that continues to inspire millions of fans today. (Licensed by: Warner Bros. Entertainment Inc. All Rights Reserved.)

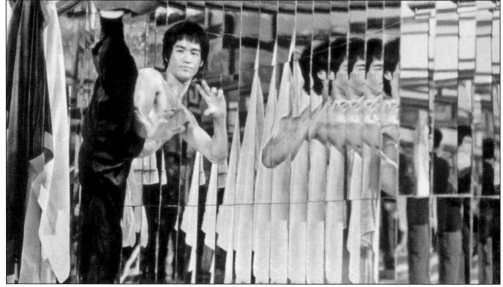

Approximately 8,000 mirrors were used to build the hall-of-mirrors set for the climactic fight scene in *Enter the Dragon*. Lee choreographed and performed the fights in the film. As the first collaboration between Warner Bros. and a Hong Kong production company, the film paved the way for future coproductions between the United States and China. (Licensed by: Warner Bros. Entertainment Inc. All Rights Reserved.)

Above, Bruce Lee takes a break during the production of *Game of Death* to spend time with his children, Shannon and Brandon. Both of Lee's children pursued careers in acting. In 1986, Brandon made his television debut in *Kung Fu: The Movie* and was nominated for a Hong Kong Film Award for his first lead role in Ronny Yu's *Legacy of Rage*. He is most remembered for his final film, *The Crow* (1992), which was completed after his accidental death on the set. Shannon started her career with a cameo in *Dragon: The Bruce Lee Story* (1993). Today, she continues her father's legacy as president of the Bruce Lee Foundation. (BRUCE LEE® and the Bruce Lee signature are registered trademarks of Bruce Lee Enterprises, LLC. The Bruce Lee name, image, likeness and all related indicia are intellectual property of Bruce Lee Enterprises, LLC. All Rights Reserved. www.brucelee.com. Bruce Lee photographs courtesy of Bruce Lee Enterprises, LLC. All Rights Reserved.)

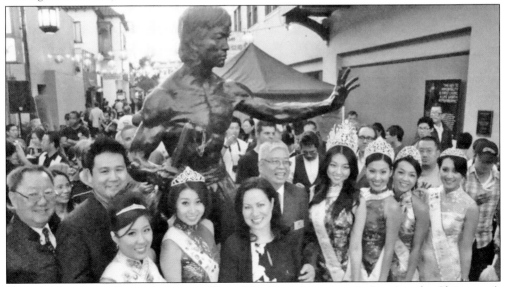

Shannon Lee (center) attends the unveiling of the Bruce Lee statue in Los Angeles Chinatown's Central Plaza on June 15, 2013. Her father ran a martial arts studio in Los Angeles Chinatown for a brief period of time. Ronald Louie (left), Jason Fujimoto, and Pres. Larry Jung of the Los Angeles Chinatown Corporation stand next to the 2013 Miss Los Angeles Chinatown Court. (Courtesy of O.C. Lee.)

Pictured here are, from left to right, Jack Ong, Beulah Quo, Pat Li, and James Hong. Quo, Li, and Hong cofounded East West Players with fellow actors Mako, Rae Creevey, Soon-Tek Oh, June Kim, Guy Lee, and Yet Lock. East West Players is a nonprofit theater organization established to provide meaningful acting, writing, producing, and directing opportunities for those who wish to explore and express Asian Pacific American experiences in theater. (Courtesy of Jack Ong.)

Playwright, writer, and screenwriter David Henry Hwang teaches a class at Fort Mason in San Francisco around 1979. Born in 1957, Hwang was exposed to the theater through his parents, who were involved with East West Players in Los Angeles. He won an Obie Award for his first play, F.O.B., which explores the tensions between Asian Americans and recently arrived immigrants. In 1988, he became the first Asian American to win the Best Play Tony Award for M. Butterfly, which also won a Drama Desk Award, a John Gassner Award, and an Outer Critics Circle Award and was nominated for a Pulitzer Prize. (Courtesy of Nancy Wong.)

Tim Dang gives a speech at the East West Players 44th Anniversary Visionary Awards "Art Is" Dinner in 2010. Dang is producing artistic director of East West Players (EWP), the premier Asian American theater organization in the United States. His involvement with EWP dates back to 1980, when he graduated from the University of Southern California with a theater degree. He has directed multiple productions, including *Chess* (2013), *Krunk Fu Battle Battle* (lyrics by Beau Sia, 2011), and *Mysterious Skin* (2010). (Photograph by Darrell Miho, courtesy of East West Players.)

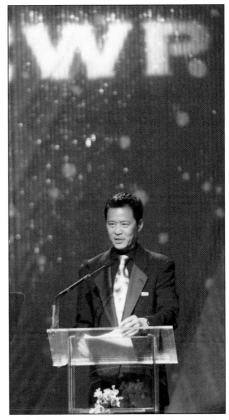

Alvin Ing (right) and Paul Wong perform in *Beijing Spring: A Musical Odyssey* at East West Players in 1999. Directed by Deborah Nishimura and Tim Dang, the production commemorated the 10th anniversary of the Tiananmen Square protests. Ing studied music at the University of Hawaii and attended Columbia University's graduate program in music education. After moving to Los Angeles, Ing joined East West Players and was signed by agent Guy Lee. His credits include *Flower Drum Song*, *The World of Suzie Wong*, *Mame*, and *Pacific Overtures*. (Courtesy of Alvin Ing.)

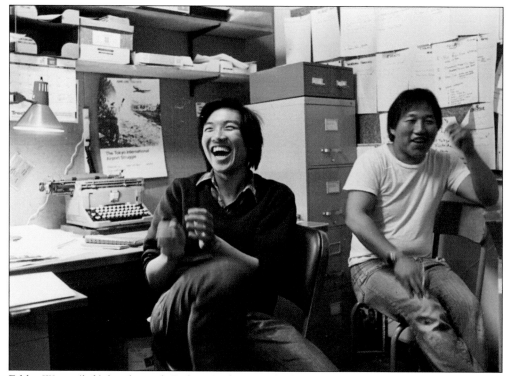

Eddie Wong (left) laughs with Robert Nakamura (right) in the former Griffith Park office of Visual Communications. Founded by Duane Kubo, Alan Ohashi, Wong, and Nakamura in 1970, Visual Communications is a nonprofit dedicated to the production, preservation, and development of media by and about Asian Pacific Americans. Nakamura was among thousands of Japanese Americans who were incarcerated in internment camps during World War II. Wong's father was a paper son from China who was detained at Angel Island. Wong served as executive director of the Angel Island Immigration Station Foundation until his retirement in 2012. (Courtesy of Visual Communications Archives.)

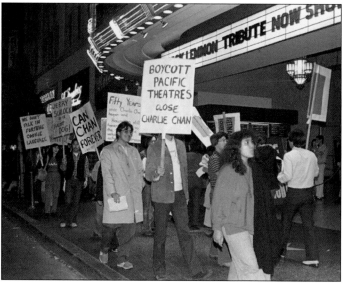

Linda Mabalot (right) marches with protestors at a screening of *Charlie Chan and the Curse of the Dragon Queen* at the Jack Lemmon Theater in Los Angeles. Steve Tatsukawa and Duane Kubo march behind Mabalot. The group objected to the portrayal of Charlie Chan by a non-Asian actor (Peter Ustinov) in yellowface. (Courtesy of Visual Communications Archives.)

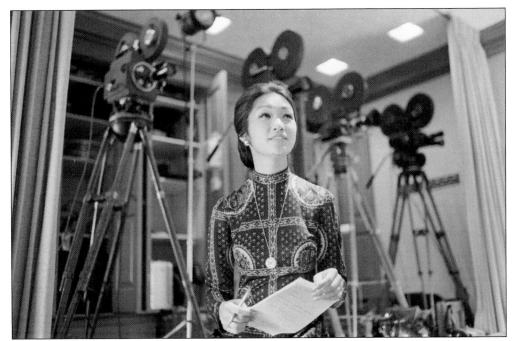

Connie Chung graduated from the University of Maryland and went on to become the most prominent Asian American journalist and television anchor of her generation. Pictured here in Washington, DC, on February 8, 1972, she reported for CBS Evening News early in her career and would later return to CBS as host of *Saturday Night with Connie Chung* and *Eye to Eye with Connie Chung*. (Courtesy of CBS/Landov.)

Curtis Choy shoots *Wendy . . . uh . . . What's Her Name* with an Eclair NPR (Noiseless Portable Reflex) 16-millimeter camera mounted on an O'Connor tripod in 1976. The film is about Wendy Yoshimura, a Japanese American artist who was born in Manzanar and gained notoriety after her arrest with heiress Patricia Hearst in 1975. Choy is known for his documentaries, including *The Fall of the I-Hotel* and *What's Wrong with Frank Chin?* He worked in the sound department on *Chan is Missing, Dim Sum: A Little Bit of Heart, Forbidden City, U.S.A., The Joy Luck Club, Better Luck Tomorrow,* and more. (Courtesy of Nancy Wong.)

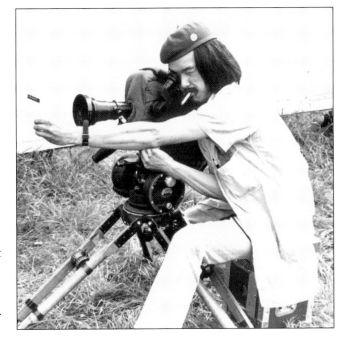

Alecia Yee Simona grew up in Hollywood and attended Le Conte Junior High School and Hollywood High School. Her mother, Cathy Yee, was cofounder of Madame Wong's nightclub in Los Angeles Chinatown. In this photograph are, from left to right, Judy Lee, Alecia Yee, Denise Wong, Mercedes ?, and Carol Mar at Le Conte Junior High School around 1974. (Courtesy of Alecia Yee Simona.)

The Los Angeles Chinese Drum and Bugle Corps (nicknamed Imperial Dragons) was founded by musician Bill Lee in 1954. It was formerly named the Chung Wah Drum and Bugle Corps after a Chinese school in Los Angeles Chinatown. The group was active until 1977, and its history is the subject of a 2014 exhibition at CHSSC. Members perform at the 1971 Moon Festival ball at the Hollywood Palladium. (Courtesy of Charles Quon.)

Born in New York City, Leland K.H. Sun is the great-grandson of Sun Yat-Sen, founder of the Republic of China. He was an actor and stunt performer for 37 years before retiring in 1997 to work at the real estate investment and consulting company owned by his father, Sun Tse-Ping. Pictured here in *The Wonderful World of Phillip Malley* (1981), he plays a Korean track runner who receives a button that causes him to float when an antigravity machine turns on. (Courtesy of Leland Sun.)

Leland Sun

Born the oldest of 13 children to Nathaniel Sr. and Olivia Wong in Gary, Indiana, Cy Wong is an actor, singer, songwriter, writer, historian, and former president of the Chinese Historical Society of Southern California. In 1962, Wong became a recording artist and songwriter with Nat King Cole's KC Recording Company in New York. His acting credits include *General Hospital, The Young and the Restless, Sanford and Son,* and *Hill Street Blues.* He is a founding member of SAG's Ethnic Minorities Committee. (Courtesy of Cy Wong.)

David Carradine played a fugitive Shaolin monk in search of his brother on the television series *Kung Fu*. Bruce Lee was considered for the role, but Carradine was ultimately cast to play Kwai Chang Caine, the son of an American man and Chinese woman. The casting decision was a disappointment to audiences who believed an Asian actor should play the role. The show did provide employment to several Asian American actors in supporting roles, including Keye Luke, shown here as Master Po. (Licensed By: Warner Bros. Entertainment Inc. All Rights Reserved.)

Pictured here on the set of *Kung Fu: The Legend Continues* are, from left to right, Kim Chan, William Dunlop, Chris Potter, and David Carradine. The show was a revival of the 1970s series *Kung Fu*. Carradine reprised his role as Kwai Chang Caine, who reunites with his long lost son—played by Potter—and joins him in fighting crime. Chan became successful as an actor later in life after having once been homeless. (Courtesy of Mo Chan and Al Leong.)

Born in Bakersfield, California, on November 29, 1946, Nathan Jung moved to Los Angeles during the first week of the Watts Riots to pursue an acting career. His brother Howard Jung and uncle Wing Lew were both actors, and Lew helped him get his start in *Laredo*. In this image, Jung plays the Dark Rider in *Kung Fu* in 1974. He appeared in *Star Trek*, *Sanford and Son*, *General Hospital*, *Big Trouble in Little China*, and more. (Photograph by Ben Makuta, courtesy of Nathan Jung.)

*One More Train to Rob* was a 1971 western film starring George Peppard. It employed several Asian American actors to play coolies who worked in the gold mines. Pictured here are, from left to right, Dawood Chung, Hayward SooHoo, Jeff Chan, and Joe Wong. (Courtesy of Jeff Chan.)

Directed by Wayne Wang, *Chan Is Missing* is a pivotal film in both Asian American and film history. Shot in San Francisco, the film established Wang's career as a director and has become a classic in Asian American cinema for its slice-of-life, nonstereotypical portrayal of Asian American characters. Pictured here outside the Garden Restaurant in San Francisco, Wood Moy (left) and Marc Hayashi (right) play two cabbies who search the streets of Chinatown for the man who stole their money. (Photograph by Nancy Wong; courtesy of Wayne Wang Productions, Inc.)

Laureen Chew and Victor Wong play Geraldine and Uncle Tam in *Dim Sum: A Little Bit of Heart*. Directed by Wayne Wang, the film tells the story of an immigrant mother who fervently hopes that her daughter will get married before she dies. The film costarred Kim Chew, Amy Hill, and Joan Chen and was nominated for the Grand Jury Prize at the Sundance Film Festival. (Photograph by Nancy Wong, courtesy of Wayne Wang Productions, Inc.)

Al Leong is an actor, martial artist, stuntman, and stunt coordinator who has worked on over 100 films. Clockwise from top left, Al Leong holds a sword next to James Hong (center, dressed as David Lo Pan) and Rick Wong (right) in *Big Trouble in Little China*, testing out a landing mat outside his apartment (Leong designed his own stunt equipment), executing a jump with double broadswords in Balboa Park, and fighting Jeff Imada (left) in a music video. Leong's other credits include *Die Hard*, *Rapid Fire*, *Bill and Ted's Excellent Adventure*, and *Lethal Weapon*. (Courtesy of Al Leong.)

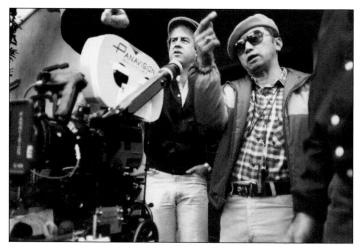

Born in Shanghai, Robert F. Liu, ASC, was honored with a 2009 Career Achievement in Television Award from the American Society of Cinematographers (ASC). Pictured here, Liu and producer/director Rod Daniel prepare to shoot a scene for the television series *The Duck Factory*. Liu's credits include *Lou Grant* and *Family Ties*. (Courtesy of Robert F. Liu, ASC.)

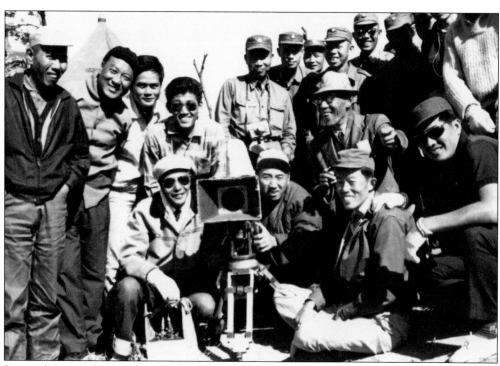

Pictured next to the camera, cinematographer Robert F. Liu, ASC, was hired by director Chuang Kuo Chuen to work for the Central Motion Picture Company in Taiwan. He went to work as an assistant director on *The Sand Pebbles* after Robert Wise visited Taiwan on a location scout. Liu earned his graduate degree from the University of Southern California and met pioneering cinematographer James Wong Howe. He and his family immigrated to the United States, where he worked at both USC and the University of California, Los Angeles (UCLA), and then transitioned to television. (Courtesy of Robert F. Liu, ASC.)

Cinematographer Edward J. Pei, ASC, prepares to shoot a scene from *The Ten Commandments* in Morocco. Originally from Taipei, Taiwan, Pei attended the graduate film program at New York University. In 1980, he was hired as second assistant cameraman on *Friday the 13th Part 2*, and he worked his way up to director of photography. In 1994, he received an Emmy nomination for *The Stand*, and he won an ASC Award for the miniseries *Streets of Laredo*. The magic of the movies inspired him to pursue a career in cinematography. (Courtesy of Edward J. Pei, ASC.)

Pictured here in Amsterdam, producer Chevy Chen prepares to film a second-unit action scene with first assistant camera Friso Pas for the third season finale of *Covert Affairs*. Chen graduated from the USC School of Cinematic Arts and became senior vice president of Master Key Productions in Los Angeles. (Photograph by Stuart E. Wall, courtesy of Chevy Chen.)

A native of Hollywood, Philip Lee attended both Le Conte Junior High School and Hollywood High School. His great-grandfather immigrated to the United States from China and worked as a railroad laborer. Lee was the school photographer and later pursued a career in cinematography. He worked as a second camera assistant on *Hoosiers* in Indianapolis. Here, he stands next to Dennis Hopper (seated) and Gene Hackman with director David Anspaugh behind camera. Lee was recovering from bronchitis and pneumonia when this scene was shot. (Courtesy of Philip Lee.)

Philip Lee (right) and camera assistant Gregor Tavenner are elevated on a Chapman Titan Crane during the filming of *The Fire Next Time* (1993). During the scene, a crowd displaced by a hurricane gets on a barge to float to safety. (Courtesy of Philip Lee.)

Hollywood residents Alyce and Robert Lee and their son Philip Lee are pictured here at a wedding reception. Robert Lee was an architect who designed multiple commercial and residential spaces in Southern California. Alyce Lee worked at Kaiser Permanente. (Courtesy of Philip Lee.)

From left to right, actors Beulah Quo, Cheng Pei-Pei, and Joan Chen participated in a panel discussion at California State University, Northridge on representations of Asian Americans in the media. Quo, a cofounder of East West Players, was highly active in promoting Asian Americans in the arts. Chen previously starred in *The Last Emperor*, and Cheng played Jade Fox in *Crouching Tiger, Hidden Dragon*. (Courtesy of Tom Eng.)

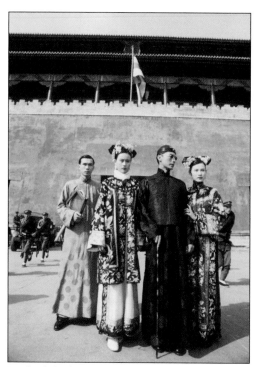

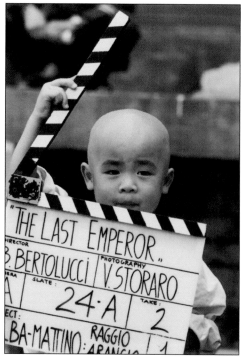

In the left photograph from Bernardo Bertolucci's *The Last Emperor*, actor John Lone plays the Chinese emperor Pu Yi as an adult, while Chinese actress Joan Chen (right) plays his wife Wan Jung, Vivan Wu plays his consort Wen Hsiu, and Fan Guang plays his brother Pu Chieh. The film won a host of prizes at the 1988 Academy Awards, including Best Picture and Best Director, as well as a Cesar in 1988 for Best Foreign Film. Actor Richard Vuu (right photograph) portrayed Pu Yi as a child. Not pictured is actor Tsou Tijger, who played Pu Yi as an older child. (Left, courtesy of © Fabian Cevallos/Sygma/Corbis; right, courtesy of © Christophe d'Yvoire/Sygma/Corbis.)

Actor John Lone visited San Francisco to promote *Iceman* in 1984. Lone was the star of *The Last Emperor*, an Academy Award–winning film about the life of Pu Yi. Born in Hong Kong, Lone joined the Peking Opera as a child and immigrated to the United States during his teenage years to further his education. He joined East West Players and was cast in David Henry Hwang's play *F.O.B.* He earned two Golden Globe nominations for his performances in *Year of the Dragon* and *The Last Emperor*. (Courtesy of Nancy Wong.)

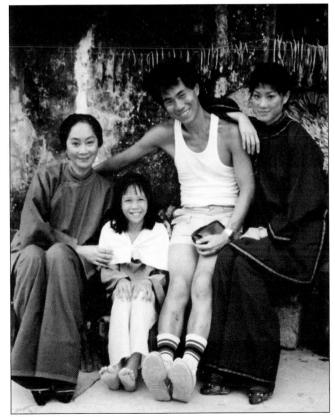

Jack Ong (left) met Dr. Haing S. Ngor (1940–1996) while filming *The Iron Triangle* (1989), and the two became lifelong friends. Ngor won an Academy Award for *The Killing Fields*. Ong is currently executive director of the Haing S. Ngor Foundation. Ngor was murdered in Los Angeles Chinatown, and his life is the subject of a documentary by filmmaker Arthur Dong. (Courtesy of Jack Ong.)

*Lotus*, a short film directed by Arthur Dong in 1987, tells the story of a Chinese mother who must choose whether or not to bind her daughter's feet. Dong was previously nominated for an Academy Award for his short documentary, *Sewing Woman*. Pictured here are, from left to right, actors Lisa Lu, April Hong, filmmaker Arthur Dong, and actor Lucia Hwong. (Courtesy of April Hong.)

91

Pictured here in Italy, Adrienne Chi-en Telemaque was one of seven American dancers known as the American Attractions on an Italian television variety show, RAI Uno's *Fantastico*. Born and raised in New York City to a Haitian father and Chinese mother, Telemaque was a ballet dancer with the Eglevsky Ballet and the San Francisco Ballet Company. Her acting career began with Tisa Chang's Pan Asian Repertory Theatre in New York City. Her manager, Jadin Wong, urged her to study other types of dance, which helped her land the role of Liat in the New York City Opera's *South Pacific*. In 1990, she was cast as Desiree on *General Hospital* and then returned to New York to perform in James Clavell's *Shogun* on Broadway. She was associate producer on Showtime's *Mr. and Mrs. Loving*, which starred Timothy Hutton and Lela Rochon. (Courtesy of Adrienne Chi-en Telemaque.)

The top photograph to the left shows Lauren Yee on the hospital set of *China Beach*, a television series that ran from 1988 to 1991. The photograph below shows her brother Kenny Yee as a child extra on *The Little Rascals* (1994). (Courtesy of Cindy Yee.)

Actor Keye Luke (1904–1991) received a star on the Hollywood Walk of Fame in 1990. Luke is well known for playing "Number One Son" Lee Chan in several Charlie Chan films and Master Po in the television series *Kung Fu*. (Courtesy of Mei Ong.)

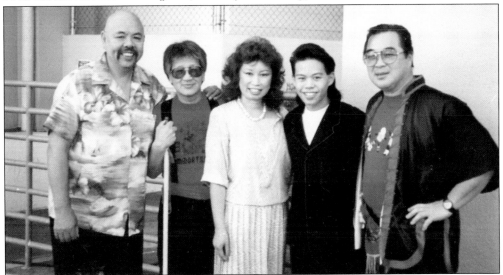

Pictured here are, from left to right, actor Richard "Curly" Sung, Eddie Kingman, Mei Ong, Ernie Reyes Jr., and Jeff Chan. Sung was born in El Paso, Texas, and moved with his family to Los Angeles Chinatown in 1941. He started out as a background player in several films and later joined East West Players. Ong was raised in Los Angeles Chinatown and became assistant director of the Los Angeles Motion Picture Coordination Office from 1984 to 1991. Reyes Jr. is a Filipino American actor, singer, martial artist, and stunt choreographer and performer. Kingman was the son of artist Dong Kingman. Chan is founder of the Immortals Lion Dance Team. (Courtesy of Mei Ong.)

*The Joy Luck Club* was a landmark film for its portrayal of realistic, nonstereotypical Asian American characters. Based on the bestselling novel by Amy Tan, it brought intergenerational stories of Chinese American families to the big screen. From left to right are Kieu Chinh, Ming-Na Wen, Tamlyn Tomita, Tsai Chin, France Nuyen, Lauren Tom, Lisa Lu, and Rosalind Chao. The film's interwoven scenes of past and present were seamlessly cut by Maysie Hoy, an editor of Chinese descent and the sister of editor William Hoy. (© 1993 Hollywood Pictures.)

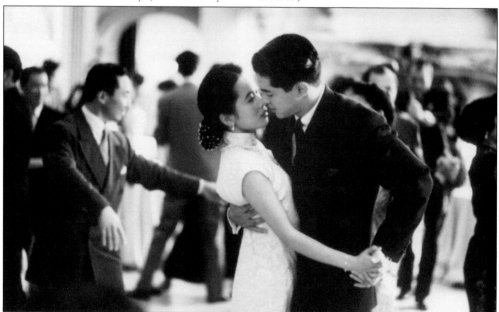

Yu Fei Hong dances with Russell Wong during a flashback scene in *The Joy Luck Club*. Hong plays Ying Ying, a mother who drowns her infant after her philandering husband, played by Wong, cheats on her. Named one of *People*'s 50 Most Beautiful People in 1995, Wong is of Chinese, Dutch, and French descent. His other credits include *Romeo Must Die*, *The Mummy: Tomb of the Dragon Emperor*, and *Snow Flower and the Secret Fan*. (© 1993 Hollywood Pictures.)

Bestselling author and producer Amy Tan smiles with award-winning screenwriter and producer Ronald Bass on the set of *The Joy Luck Club*. Both writers collaborated on the screenplay for the film. Here, Tan and Bass play party guests in a scene that featured the mothers and daughters in the movie. The set included personal items of Tan's, including a photograph of her mother and father and some decorative props. (© 1993 Hollywood Pictures.)

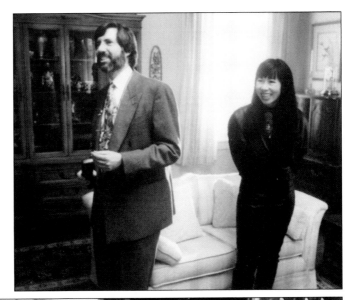

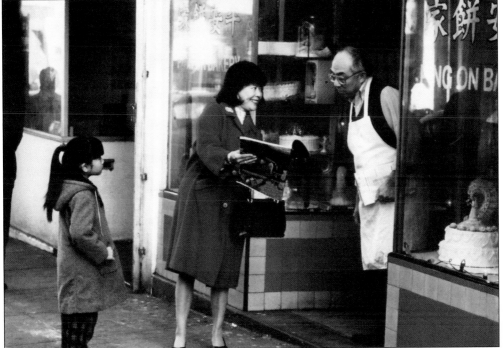

Tsai Chin's character shows off a magazine article about her daughter to actor Howard Fong, who portrays a baker in *The Joy Luck Club*. Born in Shanghai in 1936, Chin later moved to London and was cast in theatrical productions and films such as *Blowup* and the Fu Manchu films opposite Christopher Lee. She played a would-be assassin to Sean Connery's James Bond in *You Only Live Twice* and also appeared next to Daniel Craig in *Casino Royale*. She published a memoir named *Daughter of Shanghai*. Fong is a fourth-generation Chinese American from Auburn, California, whose great-grandfather was a rice broker to Chinese railroad workers in the 19th century. He always had an interest in storytelling, which inspired him to study acting with Jean Shelton in San Francisco. (© 1993 Hollywood Pictures.)

Film producer and cultural ambassador Janet Yang was executive producer of *The Joy Luck Club*. Throughout her career, she has worked to bring cross-cultural, provocative stories to the screen. Here, she stands below a marquee at the Aero Theater at a screening of *Dark Matter*, a film she produced that stars Meryl Streep and Aidan Quinn. Yang also produced *The People vs. Larry Flynt* and *High Crimes* and won an Emmy Award for *Indictment: The McMartin Trial*. (Courtesy of Janet Yang.)

In 2000, A. *Magazine* sponsored a conference on Asian Americans in the entertainment industry with panel discussions by various celebrities. Pictured here are, from left to right, panelists Garrett Wang, Rosalind Chao, Susan Hirasuna, Lisa Ling, Rick Yune, and Tim Lounibos. (Courtesy of Tom Eng.)

Born in China, Chao-Li Chi (1927–2010) attended St. John's College with a major in philosophy and also earned a graduate degree in dance education from New York University. With talents in dancing and singing, he traveled around the country with the stage production of *Flower Drum Song* and had over 50 credits in film and television during his career. As a master of tai chi, he gave lessons at the Pacific Asia Museum and also taught actor Lorenzo Lamas during several seasons of playing Angela Channing's butler on *Falcon Crest*. He also played the father to Ming-Na Wen's character in *The Joy Luck Club*. (Courtesy of the Chi family.)

Actor and director Elizabeth Sung hosted a reception for her film *The Water Ghost* in 1998. Pictured here are, from left to right, coproducer Mellissa Tong, Sung, Yi Ding, and Hiep Thi Le. Sung's acting credits include *The Young and the Restless*, *The Joy Luck Club*, *Memoirs of a Geisha*, and *Ping Pong Playa*, directed by Jessica Yu. (Courtesy of Tom Eng.)

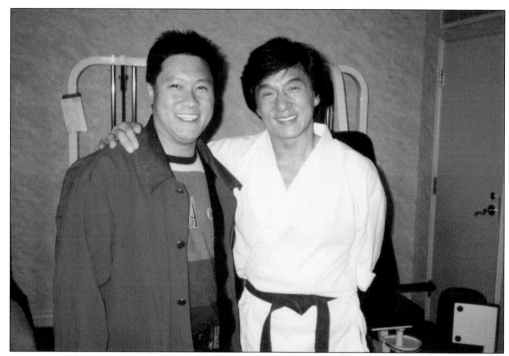

International superstar Jackie Chan (right) is pictured here on the set of *Rush Hour 2* with Glenn SooHoo, his stand-in during the film. Chan trained at the China Drama Academy with future stars Sammo Hung and Yuen Biao and appeared with Li Li-Hua in two films. He performed stunts in Bruce Lee's *Fist of Fury* and *Enter the Dragon* and later established a niche as an action-comedy star with his friends Hung and Biao. He is known for choreographing long action sequences and performing his own stunts. (Courtesy of Glenn SooHoo.)

Brandon SooHoo was cast as the lead child actor opposite Ben Stiller in *Tropic Thunder*. His great-grandfather She Wing SooHoo was a founding business owner in the Los Angeles Chinatown Corporation; his grandparents Walter and Eileen SooHoo established Phoenix Imports and Hop Louie restaurant in Central Plaza; and his father, Glenn SooHoo, has appeared in several films. (Courtesy of Paramount Pictures. TROPIC THUNDER © DW Studios, LLC. All Rights Reserved. Physical photograph courtesy of Glenn SooHoo.)

Tzi Ma points to Glenn SooHoo during a break from filming *Red Corner* at Culver Studios. Originally from Hong Kong, Ma is an accomplished actor with over 80 credits in film, television, and theater. He is well known for playing Consul Han in *Rush Hour* and *Rush Hour 3* as well as for appearing as Cheng Zhi in *24*. SooHoo is the father of actor Brandon SooHoo and the grandson of She Wing SooHoo, one of the founding members of Los Angeles Chinatown. (Courtesy of Glenn SooHoo.)

Pictured here are, from left to right, Shannon Dang, Bai Ling, Jordan Dang, and Michael Dang. Ling and the Dang siblings appeared in *Gene Generation* (2007). Born in Chengdu, Ling started acting in plays during the Cultural Revolution. Shannon Dang is a cheerleader for the Los Angeles Clippers, and Jordan Dang's credits include *Heroes* and *Angry Boys*. (Courtesy of Linda SooHoo Dang.)

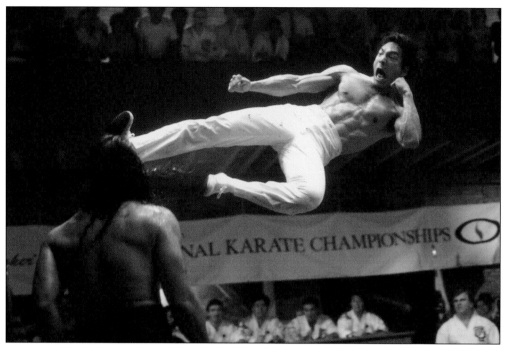

To play the lead role in *Dragon: The Bruce Lee Story*, Jason Scott Lee trained extensively in martial arts, particularly in Jeet Kune Do. Jason Scott Lee's other credits include *Back to the Future Part II*, *The Jungle Book*, *Lilo & Stitch*, and more. (Courtesy of Universal Studios Licensing, LLC.)

Actor Sammo Hung invited Miss Los Angeles Chinatown and her court to visit the set of the television series *Martial Law* in 1999. Pictured here are, from left to right, fourth princess Jenny Chen; Hung's wife, Joyce Mina Godenzi; Sammo Hung; third princess Joyce Tsang, and Miss Los Angeles Chinatown Melody Liu. (Courtesy of Tom Eng.)

Jet Li (right) poses with Hayward SooHoo on the roof of General Lee's Restaurant in Los Angeles Chinatown. With films such as *Once Upon a Time in China*, *Hero*, and many more, Li is a pioneer in the action-film genre. (Courtesy of Hayward SooHoo.)

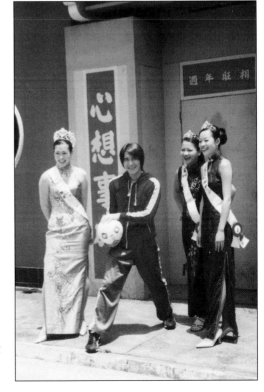

Actor and director Stephen Chow visited Chinatown's Central Plaza in Los Angeles to promote *Shaolin Soccer*. Here, he is pictured with 2003 Miss Los Angeles Chinatown Priscilla Tjio (left), third princess Joan Chang (second from right), and fourth princess Dorenda Wong. (Courtesy of Tom Eng.)

Filmmaker Arthur Dong held this press conference to promote his feature documentary *Hollywood Chinese*, which chronicles the history of representations of Chinese and Chinese Americans in Hollywood films. Pictured here are, from left to right, (first row) Peter Kwong, Tsai Chin, Arthur Dong, Nancy Kwan, and George Cheung; (second row) Elizabeth Tsing, Howard Fong, Elizabeth Sung, Aki Aleong, James Taku Leung, Nancy Yee, Karen Han, and Paul Kwo. (Courtesy of Tom Eng; *Hollywood Chinese* courtesy of Deep Focus Productions.)

Actor Peter Chen points to his name at the Comedy Store in 2012. With over 1,000 comedy shows under his belt, he performs regularly at the Comedy Store, the Laugh Factory, and the Ice House. He teaches classes in improvisation, acting, and tai chi throughout Southern California. His acting credits include *Weeds*, *24*, *50 First Dates*, and *iCarly*. (Courtesy of Peter Chen.)

This image is from *Formosa Betrayed* (2009), a feature film about the murder of a Taiwanese scientist. James Van Der Beek (center) portrays the FBI agent who is sent to Taiwan to investigate the crime and receives help from Will Tiao's character, Ming. Tiao (at left of the upper right poster) cowrote and produced the film, which had a nationwide theatrical release and a special screening for members of Congress. (Courtesy of © Formosa Films, LLC. All Rights Reserved.)

Since 1978, Jason Tong has been a performing magician at the Magic Castle in Hollywood. Originally from Hong Kong, he moved to the United States and graduated from college in 1973. He was inspired to pursue a career in magic after viewing a rope trick by a door-to-door salesman. In 1985, he was voted Magician of the Year by the International Association of Magicians. Pictured here in 2013, he is showing off a magic trick at the Close-Up Gallery of the Magic Castle. (Courtesy of Jason Tong.)

Actor Li Bing Bing, star of *Snow Flower and the Secret Fan*, greets members of OCA-LA (Organization of Chinese Americans, Los Angeles Chapter). Directed by Wayne Wang, the film was adapted from the novel by Lisa See. In the photograph are, from left to right, Jinny Hwang, Jen Ju, Li Bing Bing, Tom Eng, and William Hsu. (Courtesy of Tom Eng.)

Producer Ken Mok is the founder and president of 10x10 Entertainment. His credits include *America's Next Top Model*, *Stylista*, *Pussycat Dolls Present: Girlicious*, *Made in the USA*, *Making the Band*, and more. He began his television career at CNN before joining the crew of *The Cosby Show* and earning a spot in the NBC Associates Program. He became a network executive at NBC, director of comedy development at ABC, and vice president of productions at MTV. He is pictured with Tyra Banks at the Flawsome Ball for the Tyra Banks TZONE in New York City. (Courtesy of © Demis Maryannakis/Splash News/Corbis.)

The Immortals Lion Dance Team performed at the premiere of *Kung Fu Panda 2* (2011) in Hollywood. Pictured here are, from left to right, (first row) Jason Jay, Amie Truong, Jackie Lam, Bradley Dea, Ryan Louie, and Mark Elefane; (second row, standing) Vince Chan, Ida Lam, Dawson Wu, Karen Chu, Jeremy Wong, Jason Nguyen, Alex Dea, Kyle Nip, Erik Wong, Ryan Kawahara, Brandon Louie, Jo Paloma, Karli Cheng, and Jeff Chan. Jeff Chan is founder of the group, and his son Vince Chan carries on the tradition by training the group every week. (Courtesy of Jeff Chan/"Kung Fu Panda" © 2011 DreamWorks Animation, LLC, all rights reserved.)

Alexander Lee founded the Chinese American Club at North Hollywood High School as a sophomore. Here he is pictured with Amy Mendelsohn (center) and Lily Zhou (left).

Actor James Sie performs the role of Monkey in the Nickelodeon television show *Kung Fu Panda: Legends of Awesomeness* in 2013. Sie, who was raised in New Jersey and Pennsylvania, joined a Chicago theater company after graduating from Northwestern University. His Chinese and Italian heritage inspired him to write the one-man show *Talking with My Hands*, which premiered at A-Fest, a performance series at Seattle's Northwest Asian American Theatre, in 2001. (Photograph by Peter Hastings, courtesy of James Sie.)

Beau Sia was called "the one-man Led Zeppelin of modern poetry" by director Jonathan Demme, who cast him in *Rachel Getting Married*. Raised by Chinese parents from the Philippines, Sia moved from Oklahoma to New York City, where he became part of a vibrant performance scene at the Nuyorican Poets Café. He appeared in the documentary *SlamNation* as part of the Nuyorican National Poetry Slam team. He won new fans with his critically acclaimed satire of Jewel's poetry, *A Night without Armor II: The Revenge*. His 2013 book is called *The Undisputed Greatest Writer of All Time.*

Born and raised in San Francisco, Page Leong began her career as a dancer and later transitioned to acting. Her grandparents immigrated to the United States from Canton, China, and settled in San Francisco, where her grandfather served as a minister for the Chinese Congregational Church. After earning undergraduate and graduate degrees in dance from UCLA, Leong began working at the Los Angeles Theater Center and cofounded the Raven Group. She joined the Cornerstone Theater Group and displayed her skills in writing, directing, and choreography with their support. To date, Leong has acted in over 60 plays. Her screen credits include *Ghostbusters II*, *Another 48 Hrs.*, *China Beach*, and *Star Trek: The Next Generation*. In 2012, she played Pat Taylor in *Argo* and Mrs. Yun in *The Bourne Legacy*. (Courtesy of Page Leong.)

From left to right are actors Jack Ong, Lisa Lu, and Teddy Chen Culver, who play the Yi family on *General Hospital*. Ong and Culver also starred together with Patty Toy in *Journey of a Paper Son*, a film directed by Ming Lai about a dying man's wish to change his "paper name" to his real name. Culver is also a writer and director whose first film *The Boxer* won the CAPE/Spike TV Digital Shorts Contest. (Courtesy of Jack Ong; *General Hospital* © American Broadcasting Companies, Inc.)

Lucy Liu films *Elementary* in New York City with Jonny Lee Miller in 2012. Originally from Queens, New York, Liu became one of the most prominent Chinese American actresses of her generation after being cast as Ling Woo on *Ally McBeal*. She successfully crossed over to feature films with starring roles in *Kill Bill*, *Charlie's Angels*, *Charlie's Angels: Full Throttle*, *Shanghai Noon*, *Lucky Number Slevin*, the Kung Fu Panda films, and more. (Courtesy of © Splash News/Corbis.)

In 1985, actor Kelly Hu became the first Asian American to win the Miss Teen USA pageant. Her early television credits include *Growing Pains*, *Night Court*, *21 Jump Street*, and *Nash Bridges*. She costarred with Sammo Hung in *Martial Law*, one of the rare shows at the time to feature two Asian American lead actors. In *X2*, she showcased her martial arts skills as the iconic Lady Deathstrike. She is pictured here as grand marshal of the 2005 Chinese New Year parade in Los Angeles Chinatown. (Courtesy of Tom Eng.)

Born in Honolulu and raised by his grandparents, Keone Young is Chinese on his father's side and Japanese on his mother's side. While in Hawaii, he began his career as part of the stage-and-lighting crew in community theater productions before transitioning to acting. In 1965, he moved to California to study at the Pasadena Playhouse College of Theater Arts. This photograph shows Young as Mr. Wu on the HBO television series *Deadwood* (2004–2006). His other credits include *Men in Black 3*, *The Young and the Restless*, *Avatar: The Last Airbender*, *Alias*, and *Challenger*, where he portrayed astronaut Ellison Onizuka. (Courtesy of HBO/Doug Hyun. HBO® and Deadwood[SM] are service marks of Home Box Office, Inc.)

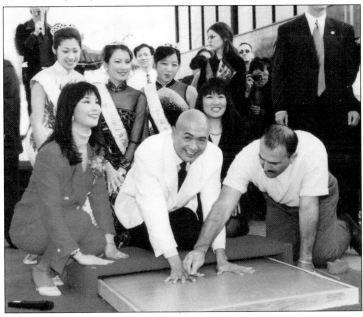

Chow Yun-Fat's handprint ceremony occurred in Chinatown's Central Plaza as part of a promotional tour for *Anna and the King* (1999). He was joined by Miss Los Angeles Chinatown and her court. At left is Miranda Ho Chan, a longtime supporter of community activities in Southern California and host of the event. (Courtesy of Jeff Chan.)

Director Henry Chan (center) and screenwriter and actor Alan Yang (right) were guest speakers at the C3: Conference for Creative Content at the Writers Guild of America in 2012. Chan received an Emmy Award for Outstanding Editing for a Series—Multi-Camera Production for *The Cosby Show*. His directing credits include *A Different World*, *Moesha*, *The King of Queens*, *Scrubs*, *Whitney*, and more. Yang is a staff writer and recurring actor on NBC's *Parks and Recreation*. The panel was moderated by television executive Quan Phung (left), a Vietnamese American and board member of Visual Communications.

Originally from San Francisco, screenwriter Alex Tse cowrote the script for *Watchmen*, directed by Zack Snyder. He previously wrote *Sucker Free City*, which was directed by Spike Lee for Showtime and won a PEN Center USA award for best teleplay. (Courtesy of Jonathan Wolf.)

Jodi Long is pictured here, center, with the cast of *Sullivan and Son*, a multicamera sitcom about a multiracial Korean and Irish American family. Pictured are, from left to right, (first row) Christine Ebersole, Brian Doyle-Murray, and Vivian Bang; (second row) Dan Lauria, Steve Byrne, Jodi Long, and Ahmed Ahmed. (Courtesy of Ture Lillegraven TM & © Turner Entertainment Networks, Inc. A Time Warner Company. All Rights Reserved.)

Originally from New York City, Brenda Hsueh is a writer and producer who launched her television career after receiving the ABC Writing Fellowship. She wrote for *Oliver Beene* and *The Men's Room* before joining the writing staff of *How I Met Your Mother*. In 2010, she produced the television series *Melissa & Joey*, and she later became executive producer of the sitcom *Sullivan and Son*. (Courtesy of Brenda Hsueh.)

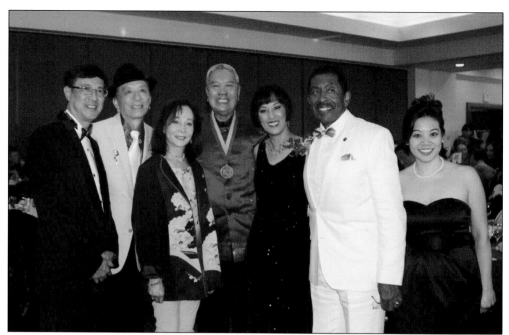

Pictured are, from left to right, magician Jason Tong; actors James Hong, Nancy Kwan, Jack Ong, Patty Toy, and Cy Wong; and author Jenny Cho at the 2013 Golden Spike Awards sponsored by the Chinese Historical Society of Southern California. Ong and Wong were honored for lifetime achievement in community service. Ong performed "I Enjoy Being Chinese" at the event with Kwan, star of *Flower Drum Song* and *The World of Suzie Wong*. Toy is a Chinese American actress from West Los Angeles whose father, Larry, was born in Guangdong, China; mother, Margaret, was born in Downey, California; and paternal grandfather was born in Bakersfield, California.

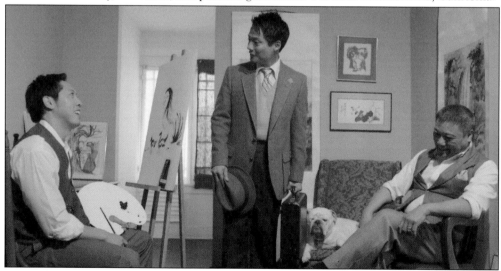

Directed by Timothy Tau, *Keye Luke* is a short biopic about the pioneering late actor. Pictured from left to right are Feodor Chin (Keye Luke), Archie Kao (younger brother Edwin Luke), and Kelvin Han Yee (father Lee Luke). In this scene, Keye Luke complains to his father about not being able to move to California like his other relatives. The film recreated the Luke family's art shop in 1925 Seattle. (Still from *Keye Luke* [2012]; cinematography by Rick Darge; courtesy of Timothy Tau.)

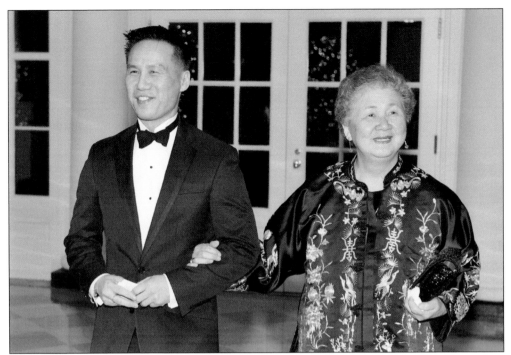

Actor B.D. Wong and his mother, Roberta Wong, attended the state dinner for China's president Hu Jintao in Washington, DC. As Song Lilling in M. *Butterfly*, Wong won a Tony Award, a Drama Desk Award, a Theater World Award, and a Clarence Derwent Award for Most Promising Male. He has played Dr. George Huang on *Law & Order: Special Victims Unit* for over 10 seasons, and he starred as Fr. Ray Mukada on *Oz*. (Courtesy of © Ron Sachs/CNP/Corbis.)

The documentary *Linsanity* premiered at the Sundance Film Festival in 2013. The film tells the story of Jeremy Lin, a Harvard graduate who skyrocketed to fame as a basketball player with the New York Knicks before moving to the Houston Rockets in 2012. From left to right are Jeremy Lin, director Evan Jackson Leong, and producers Allen Lu, Christopher Chen, and Brian Yang. (Courtesy of Kenji Tsukamoto.)

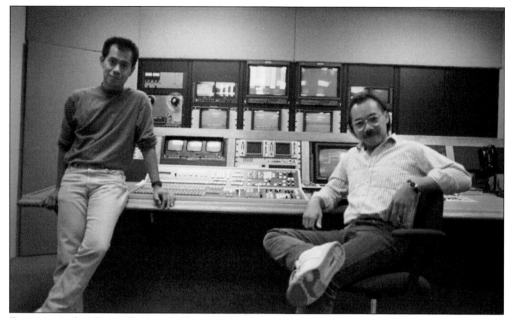

Director Arthur Dong (left) and editor Walt Louie (right) collaborated on the documentary film *Claiming a Voice* (1990), which celebrated the first 20 years of Visual Communications. They are pictured here during postproduction at KSCI in Santa Monica, California. A San Francisco native, Louie is the owner of Flash Cuts, an editorial studio based in Los Angeles that provides creative-content advertising services for a variety of clients. (Courtesy of Visual Communications Archives.)

Editors Jean Tsien, ACE (American Cinema Editors; right), and Kate Amend, ACE (left), attend the 2013 Eddie Awards at the Beverly Hilton. Born in Taiwan and raised in New York City, Tsien was inspired to become an editor after attending a lecture by her New York University editing instructor, Paul Barnes. Tsien's credits include *My America . . . or Honk If You Love Buddha*, *Scottsboro: An American Tragedy*, *Shut Up & Sing*, and more. (Courtesy of Jean-Philippe Boucicaut.)

Photographed at his Avid bay (an editorial workstation) in 2013, William Hoy, ACE, is a motion picture feature editor based in Los Angeles. He is renowned for his work with director Zack Snyder on the films *300, Watchmen, and Sucker Punch*. He is editor of *Dawn of the Planet of the Apes*, and his sister is film editor Maysie Hoy, ACE. (Courtesy of William Hoy.)

Maysie Hoy, ACE, is pictured here at her editing suite in 2013. As an actor, Hoy was cast in *McCabe & Mrs. Miller* (1971) and subsequently was hired as an apprentice editor by director Robert Altman. She is the sister of film editor William Hoy, ACE. (Photograph by Jonathan Talactac, courtesy of Maysie Hoy.)

Lynn Chen, Alice Wu, Joan Chen, and Michelle Krusiec (shown here from left to right) arrive for the premiere of *Saving Face* at the Loews 19th Street Theater in New York City. Directed by Alice Wu, the film tells the story of a woman who comes out as a lesbian to her conservative Chinese community in New York City. Actor and filmmaker Joan Chen starred in *The Last Emperor* and directed *Xiu Xiu: The Sent Down Girl*. Krusiec has appeared in several films and television shows, including *What Happens in Vegas* and *Weeds*. (Courtesy of UPI Photo/Laura Cavanaugh.)

Teddy Zee is a leading advocate in promoting Asian American talent behind and in front of the camera. He was executive vice president of production at Columbia Pictures, which brought Chow Yun Fat (*Replacement Killers*) and Lucy Liu (*Charlie's Angels*) to the big screen. At Overbrook Entertainment, he produced *The Pursuit of Happyness* and *Hitch*, both starring Will Smith. He also championed *Saving Face*, the directorial debut of Alice Wu. (Courtesy of Teddy Zee.)

Director Jon M. Chu graduated from the University of Southern California School of Cinematic Arts and is one of the most successful directors of his generation, especially in 3-D. Raised by parents from Hong Kong and Taiwan, he learned a strong work ethic at a young age and was encouraged to pursue his interests in the arts. He received his first feature directing assignment with *Step Up 2: The Streets*, followed by *Step Up 3D*. He directed the documentary *Justin Bieber: Never Say Never* and soon thereafter was hired by Paramount Pictures to direct *G.I. Joe: Retaliation*. (Courtesy of Paramount Pictures. G.I. JOE: RETALIATION © Paramount Pictures Corp. All Rights Reserved.)

Born in Costa Rica, actor, singer, choreographer, and dancer Harry Shum Jr. is trilingual in Spanish, Chinese, and English. He began his career as a dancer and was cast in *Step Up 2: The Streets* and *Step Up 3D*, among others. He catapulted to fame as Mike Chang on *Glee* and received the 2011 Breakout Performance Award from East West Players for his positive impact on the Asian Pacific American community. (Courtesy of Riker Brothers.)

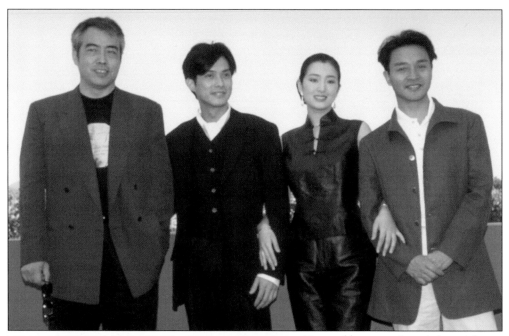

Pictured here are, from left to right, director Chen Kaige, Kevin Lin, Gong Li, and Leslie Cheung at the Cannes Film Festival. Chen directed the actors in *Temptress Moon*. Chen also directed Li and Cheung in *Farewell My Concubine*. Cheung was an extraordinarily talented actor who committed suicide in 2003. (Courtesy of © Stephane Cardinale/Sygma/Corbis.)

Born in Canton, China, John Woo overcame abject poverty to become one of the most renowned directors working today. His filmmaking style influenced Quintin Tarantino, Robert Rodriguez, Oliver Stone, and more. Pictured here on set, he was invited to direct *Mission: Impossible II* (2000) by Tom Cruise after the box office success of Woo's *Face/Off*. (Courtesy of Paramount Pictures. MISSION: IMPOSSIBLE II © Paramount Pictures. All Rights Reserved.)

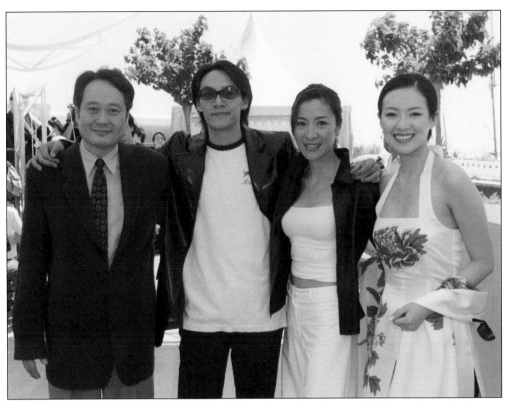

Director Ang Lee and the cast of *Crouching Tiger, Hidden Dragon* attended the Cannes Film Festival on May 19, 2000. Seen here are, from left to right, Ang Lee, Chang Chen, Michelle Yeoh, and Zhang Ziyi. The film was celebrated for presenting strong female protagonists and won four Academy Awards, including Best Foreign Language Film. (Courtesy of © Cardinale-Robert/Sygma/Corbis.)

Director Wong Kar Wai (right) appeared with the cast of *In the Mood for Love* at the Cannes Film Festival on May 20, 2000. The film was a visual poem about the forbidden love between a married woman and a bachelor. Second and third from the left are stars Tony Leung and Maggie Cheung. (Courtesy of © Cardinale-Robert/ Sygma/Corbis.)

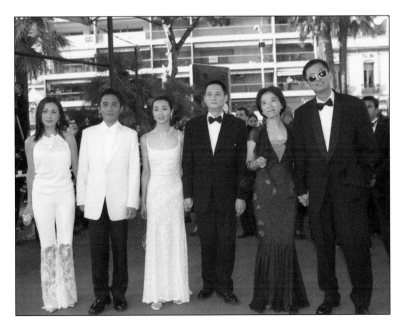

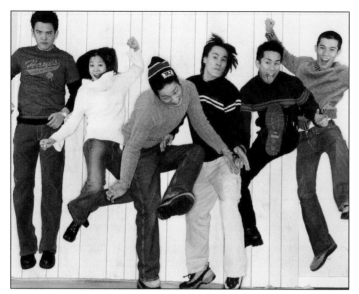

Directed by Justin Lin, *Better Luck Tomorrow* was a groundbreaking film that featured an all–Asian American cast. From left to right are John Cho, Karin Anna Cheung, Sung Kang, Roger Fan, Parry Shen, and Jason Tobin. The film told the story of overachieving high school students who become involved in criminal activities. Cho and Kang are of Korean descent. The film launched Lin's directing career. (Courtesy of © Erin Patrice O'Brien/Corbis.)

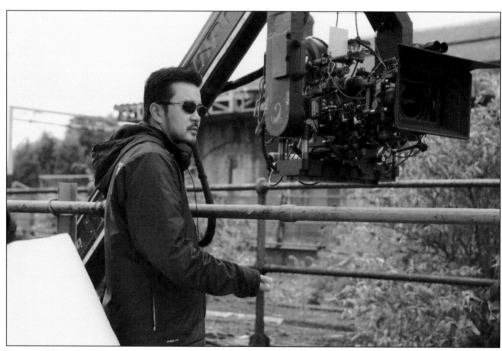

Pictured here is director Justin Lin on the set of *Fast and Furious* 6. His credits include four films to date in the Fast and Furious franchise, *Finishing the Game: The Search for a New Bruce Lee*, *Annapolis*, episodes of the NBC series *Community*, and more. He is a founding partner of *You Offend Me You Offend My Family*, a Web site that promotes and distributes media primarily related to Asian American popular culture. (Courtesy of Universal Studios Licensing, LLC.)

# *Five*

# ACADEMY AWARDS

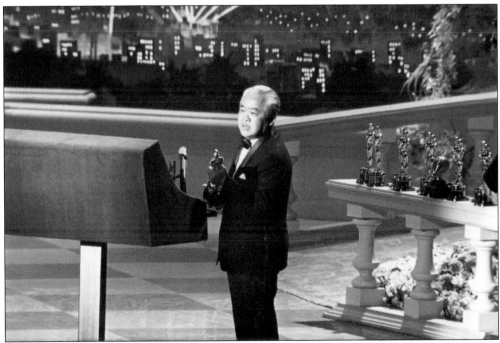

James Wong Howe accepts the Academy Award for Cinematography for *Hud* (1963), starring Paul
Newman and Patricia Neal. Howe earned his first Academy Award for *The Rose Tattoo* (1955) and
received a total of 10 nominations in his lifetime. (Photograph from the collections of the Margaret
Herrick Library, courtesy of Copyright © Academy of Motion Picture Arts and Sciences.)

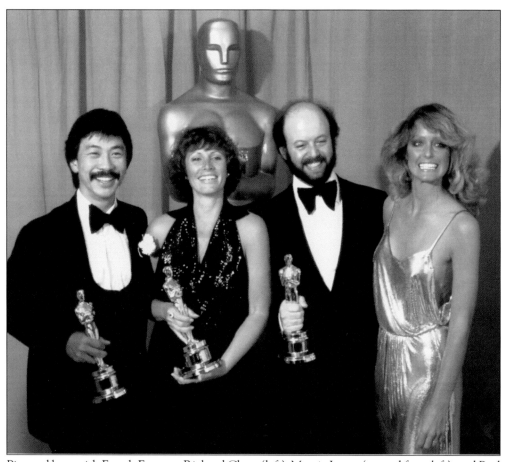

Pictured here with Farrah Fawcett, Richard Chew (left), Marcia Lucas (second from left), and Paul Hirsch (third from left) won the Academy Award in Film Editing for *Star Wars* (1977). Chew had previously received an Oscar nomination for *One Flew Over the Cuckoo's Nest* (1975). (Photograph from the collections of the Margaret Herrick Library, courtesy of Copyright © Academy of Motion Picture Arts and Sciences.)

Arthur Dong (second from left) and Young Gee, Dong's husband, hold the auto pass to the Academy Awards ceremony on April 9, 1984. Dong was nominated for an Academy Award in Documentary (Short Subject) for *Sewing Woman* (1983), cowritten by his sister Lorraine Dong, PhD (at right, holding Elan Hom's hand). Dong's career exemplifies a commitment to exploring and preserving Asian American history. (Courtesy of Marlon K. Hom.)

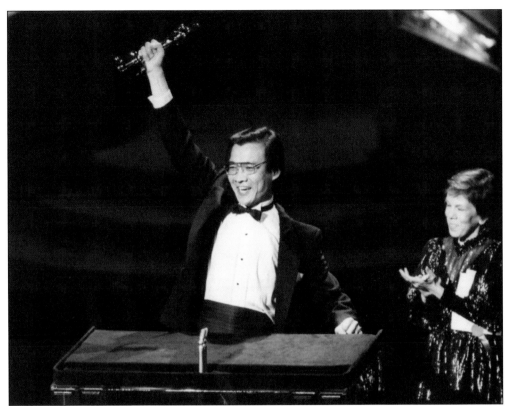

Actor Haing S. Ngor accepts the Academy Award for Actor in a Supporting Role for *The Killing Fields* (1984). Ngor, a refugee from Cambodia, was tragically gunned down in Los Angeles Chinatown. His legacy has been preserved by the Haing S. Ngor Foundation, led by executive director Jack Ong. A documentary about Ngor's life is being directed by Arthur Dong. At right is presenter Linda Hunt. (Photograph from the collections of the Margaret Herrick Library, courtesy of Copyright © Academy of Motion Picture Arts and Sciences.)

Cong Su (right) shared the Academy Award for Music (Original Score) for *The Last Emperor* (1987). He is pictured here with Ryuichi Sakamoto (left) and David Byrne at the 60th Academy Awards ceremony. (Photograph from the collections of the Margaret Herrick Library, courtesy of Copyright © Academy of Motion Picture Arts and Sciences.)

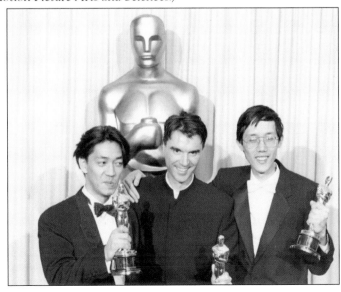

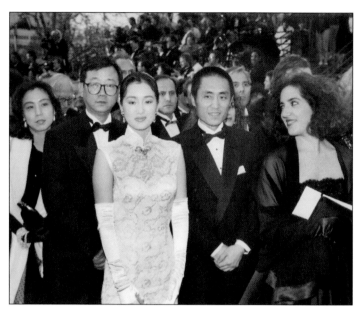

Director Zhang Yimou and actor Gong Li arrive at the 64th Academy Awards in 1992. Yimou directed Li in *Raise the Red Lantern*, which had been nominated for Foreign Language Film (Hong Kong). His films *Ju Dou* (1990) and *Hero* (2002) have been nominated for Best Foreign Language Film for the People's Republic of China. (Photograph from the collections of the Margaret Herrick Library, courtesy of Copyright © Academy of Motion Picture Arts and Sciences.)

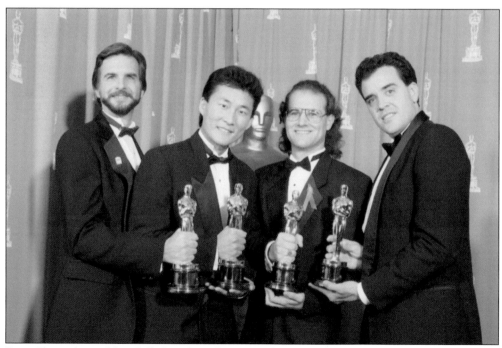

Doug Chiang (second from left) shared Academy Award for Visual Effects for *Death Becomes Her* (1992). He is pictured here with Ken Ralston (left), Doug Smythe (second from right), and Tom Woodruff Jr. at the 65th Academy Awards ceremony. (Photograph from the collections of the Margaret Herrick Library, courtesy of Copyright © Academy of Motion Picture Arts and Sciences.)

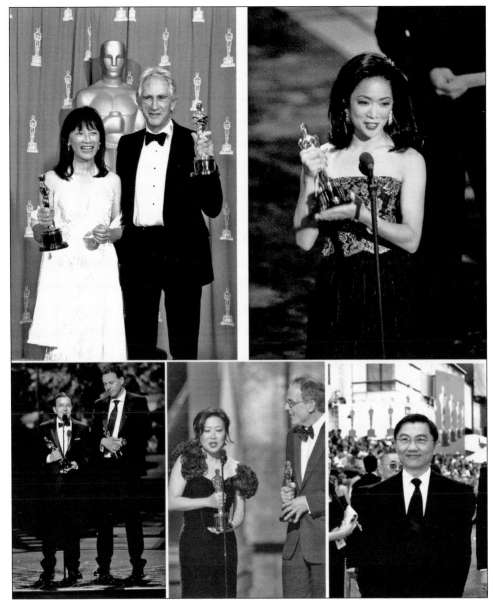

Freida Lee Mock and Terry Sanders (top left) won an Academy Award for Best Documentary Feature for *Maya Lin: A Strong Clear Vision* (1994). Mock was also nominated for *To Live or Let Die* (1982), *Rose Kennedy: A Life to Remember* (with Terry Sanders, 1990), *Never Give Up: The 20th Century Odyssey of Herbert Zipper* (with Terry Sanders, 1995), and *Sing!* (with daughter Jessica Sanders, 2001). Director Jessica Yu (top right) won for Documentary (Short Subject) for *Breathing Lessons: The Life and Work of Mark O'Brien* (1996). Shaun Tan and Andrew Ruhemann (bottom left) won an Academy Award for Best Short Film (Animated) for *The Lost Thing* (2010). Ruby Yang and Thomas Lennon won for Documentary (Short Subject) for *The Blood of Yingzhou District* (2006) and were also nominated for *The Warriors of Qiugang* (2010). Chung Man Yee (bottom right) was nominated for Best Costume Design for *Curse of the Golden Flower* (2006). (Photographs from the collections of the Margaret Herrick Library, courtesy of Copyright © Academy of Motion Picture Arts and Sciences.)

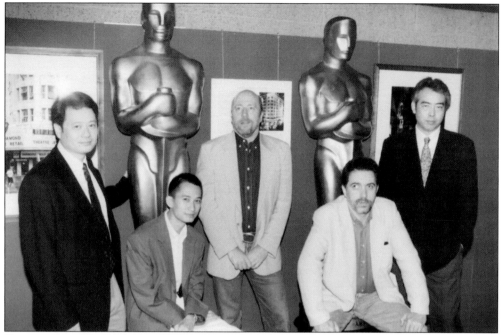

Directors Ang Lee (far left) and Chen Kaige (far right) pose on either side of the 1993 Academy Award nominees for Foreign Language Film. They are, from left to right, Tran Anh Hung, Paul Turner, and Fernando Trueba. Lee had been nominated for *The Wedding Banquet* (Taiwan) and Chen for *Farewell My Concubine* (Hong Kong). (Photograph from the collections of the Margaret Herrick Library, courtesy of Copyright © Academy of Motion Picture Arts and Sciences.)

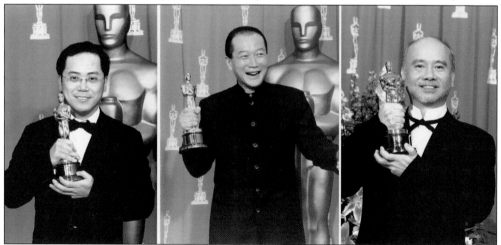

These are three Academy Award winners for *Crouching Tiger, Hidden Dragon* (2000). Production designer Tim Yip (left) won for Art Direction and also was nominated for Costume Design. Tan Dun (center) won for Original Score and was nominated for Original Song for "A Love Before Time," sung by Coco Lee at the awards ceremony. Cellist Yo-Yo Ma was also featured on the sound track and performed live with Itzhak Perlman during the show. Peter Pau (right) won for Cinematography. Born in Hong Kong, Pau also worked with director John Woo on *The Killer* and with actors Jackie Chan and Jet Li on *Forbidden Kingdom*. (Photographs from the collections of the Margaret Herrick Library, courtesy of Copyright © Academy of Motion Picture Arts and Sciences.)

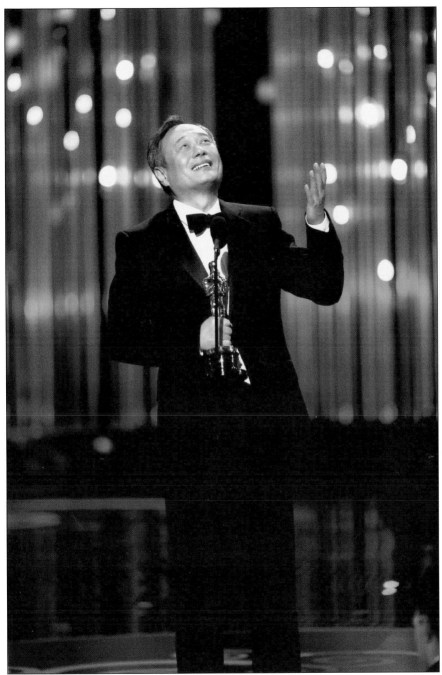

In 2013, Ang Lee received an Academy Award for directing *Life of Pi*; it was his second directing award after winning for *Brokeback Mountain* (2005). His films *The Wedding Banquet* (Taiwan, 1993) and *Eat Drink Man Woman* (Taiwan, 1994) had previously been nominated for Best Foreign Language Film, along with Academy Award winner *Crouching Tiger, Hidden Dragon* (Taiwan, 2000). The latter film received 10 Academy Award nominations, including Best Picture (nominated with Bill Kong and Hsu Li Kong) and Best Director for Ang Lee. (Photograph from the collections of the Margaret Herrick Library, courtesy of Copyright © Academy of Motion Picture Arts and Sciences.)

# Discover Thousands of Local History Books Featuring Millions of Vintage Images

Arcadia Publishing, the leading local history publisher in the United States, is committed to making history accessible and meaningful through publishing books that celebrate and preserve the heritage of America's people and places.

## Find more books like this at
## www.arcadiapublishing.com

Search for your hometown history, your old stomping grounds, and even your favorite sports team.